teach yourself®

calligraphy
patricia lovett

For over 60 years, more than 40 million people have learnt over 750 subjects the **teach yourself** way, with impressive results.

be where you want to be
with **teach yourself**

acknowledgements

I am very grateful to Chris Marsh for taking very high quality photographs and being such a helpful asset while they were being taken. Thanks are also due to Samantha Baldwin and Tiwi Urquart-Stewart for assisting at the photo-shoot and being 'the hands' in one case and 'the body' in another.

I would also like to thank the British Library for allowing me to use photographs of their manuscripts and for always being so helpful when photographs of manuscripts are needed – my gratitude extends particularly to Catherine Britton, Kathleen Houghton, Lara Speicher and David Way.

Michelle Brown, Curator of Illuminated Manuscripts at the British Library, is such a positive force for all things to do with manuscripts that it is difficult not to catch her enthusiasm. I am delighted and honoured that she has written the foreword to this book.

Thanks are also due to my family who have cheerfully accepted the fact that I am too often with a pen in my hand, and have an incurable obsession for letters and lettering.

Patricia Lovett

For UK order enquiries: please contact Bookpoint Ltd, 130 Milton Park, Abingdon, Oxon OX14 4SB.
Telephone: (44) 01235 827720. Fax: (44) 01235 400454. Lines are open from 09.00–18.00, Monday to Saturday, with a 24-hour message answering service. You can also order through our website www.madaboutbooks.com

For USA order enquiries: please contact McGraw-Hill Customer Services, PO Box 545, Blacklick, OH 43004-0545, USA.
Telephone: 1-800-722-4726. Fax: 1-614-755-5645.

For Canada order enquiries: please contact McGraw-Hill Ryerson Ltd, 300 Water St, Whitby, Ontario L1N 9B6, Canada.
Telephone: 905 430 5000. Fax: 905 430 5020.

Long renowned as the authoritative source for self-guided learning – with more than 30 million copies sold worldwide – the *Teach Yourself* series includes over 300 titles in the fields of languages, crafts, hobbies, business, computing and education.

British Library Cataloguing in Publication Data:
A catalogue record for this title is available from The British Library

Library of Congress Catalog Card Number: On file

First published in UK 2003 by Hodder Headline Ltd, 338 Euston Road, London, NW1 3BH.

First published in US 2003 by Contemporary Books, a Division of The McGraw-Hill Companies, 1 Prudential Plaza, 130 East Randolph Street, Chicago, IL 60601 USA.

The 'Teach Yourself' name is a registered trade mark of Hodder & Stoughton Ltd.

Typeset by Dorchester Typesetting Group Ltd
Printed in Dubai for Hodder & Stoughton Educational, a division of Hodder Headline Ltd., 338 Euston Road, London NW1 3BH by Oriental Press.

Impression number 10 9 8 7 6 5 4 3 2 1

Year 2009 2008 2007 2006 2005 2004 2003

contents

curator of illuminated manuscripts at the british library

foreword by Michelle P. Brown

Writing is an important mode of communication, not only in terms of the words it preserves and transmits, but in terms of its visual appearance. From ancient times it has been recognized that words exert a powerful impact, as sign and symbol, and that the physical act of writing can be practised as an art form – calligraphy (from the Greek for 'beautiful writing').

Before the introduction of printing to the West during the fifteenth century, and for many types of books and documents even long after that date, writing and its decoration (illumination) were produced by hand. Their appearance evolved in response to the materials used and to changes in the history of the societies that made and used them, and in their taste and aspirations. Prior to the rise of the towns and universities from around 1200, writing was principally the domain of the Church, produced by monks and nuns working in the scriptorium or, occasionally, in comparative solitude as hermits (as in the case of Bishop Eadfrith who made the Lindisfarne Gospels around 715–20). After 1200 book production became increasingly a specialized urban activity (although books were still made by clerics too), with work sub-contracted to scribes and illuminators by the stationers from whom books were ordered. Very occasionally authors would resort to the unusual practice of writing their own works, as in the case of Christine de Pisan, a young widow in early fifteenth-century Paris. Even after printing became the norm, fine books were sometimes hand-made by artists such as William Morris and in the late nineteenth and twentieth centuries there was a revival in the art of calligraphy, allowing it once more to assume an important role in art and design. As more people gained the skill of writing themselves, so handwriting has become a revealing aspect of personality and style, saying as much about you as the way you look.

Calligraphy can bring much creativity and pleasure into the lives of those who practise and who appreciate it. This attractive, imaginative, yet practical book conveys a fundamental enthusiasm for the art and explores numerous perspectives. It is bursting with ideas for the use of writing in activities and in the making of gifts to delight. With beautifully laid out pages and clearly illustrated procedures it has much to offer the teacher, student and current practitioner alike. Practical techniques and their aesthetic application are given equal weight in this pleasing book by a leading calligrapher whose work has brought me great happiness in the past and whose approach combines the talent of an artist, the skill of a craftsperson and the knowledge of a scholar.

Calligraphy can be structured and contained, or flamboyant and exuberant. Writing implements affect the shapes of the letter-forms, and can help to create a mood or feeling.

Calligraphy is one of the most easily accessible of all the arts and crafts as you can start with so few items of equipment and these are readily available – a broad-edged nib, pen, ink and paper. Many art shops and stationers sell felt tip calligraphy pens, calligraphy fountain pens or calligraphy dip pen sets. With calligraphy dip pens you can use fountain pen ink, calligraphy ink, or gouache paint which is bought in tubes and then mixed with water. When it comes to papers, even plain photocopying paper can be a suitable surface for practising letters.

Once you feel happy with writing letters and words in just one writing style, you can put your newly found calligraphy skills to good use. Most people are impressed if they receive a hand-made card or gift. Cards for greetings or celebration using only one letter are easy to make. Imagine the delight in the eyes of your friends and relatives when that card is matched to wrapping paper for the present and a gift tag. If the gift itself is a hand-made book which reflects their favourite colours, with selected text or blank for your friend's own thoughts and jottings, the personal touch which you have expended on their celebration is complete.

Everyone will want to accept an invitation which is well-written and hand-crafted, even though the end result may have been copied using a photocopier or computer. Matching the menu and place names to the invitation, too, adds individuality to the event.

However, calligraphy can be so much more than greetings for friends or writing out invitations. Many people are moved by poetry or sections of prose, and calligraphy gives you the opportunity to interpret words in the colours and style of writing which you feel best suit the mood and character of the piece. Words that give the feeling of calm and restfulness can be written out in soothing colours with a layout that suggests peace. Lively words can be interpreted in vibrant colours and letter-forms which jump from the page. The background and choice of paper all contribute to making an artwork which is completely unique. Perhaps the trouble with calligraphy is that it can become so addictive, because it is eminently enjoyable, and soon you will find it difficult to stop producing lettering for yourself and others.

tools and materials

There are three essential items which you need to start calligraphy – a pen, ink and paper. This chapter explains how to choose the best equipment for you, and how to select other tools and materials which will make it easier and simpler to create good calligraphic letters.

Pens

The essential tool that you will need to make the letter-forms in this book is a broad-edged pen. For right-handers, this is a pen which is cut straight across the nib tip; for left-handers, it is often more comfortable to use a pen which is left-oblique, where the nib slants down to the left.

Calligraphy felt tips, fountain pens and dip pens are all available with a broad-edged nib or tip, and the two last are often available as left-oblique for left-handers. Felt tip pens and fountain pens are ideal for practising letter-forms. You will not have to worry about ink spilling, and you can work on your letters simply by picking up the pen and writing.

Calligraphy dip pens are a little more complicated, but they will give you the best letter-forms, as these will be crisp and sharp, with spine-tinglingly thin and well-defined fat parts to the letters. The pens are usually available with a selection of nibs of different widths, which means that you have a choice of sizes of letters as letter sizes are determined by the width of the nib.

However, these pens do need to be assembled, and have to be fed with ink.

Most calligraphy dip pens come in three parts – the pen holder, the nib and a flexible slip-on reservoir. (Some calligraphy pens have the reservoir attached to the nib itself). The nib should be pushed into the pen holder so that it is firm. If there are metal prongs inside the pen holder, make sure that the nib is secure between these and the outer casing. If not, the nib will wobble and it will be difficult to write. It sometimes helps if you push the nib in its pen holder straight down on a flat surface, but take care here as the nib may bend if you are too vigorous when pressing down.

The slip-on reservoir slides on underneath the nib, and should sit with the rounded v-shaped tip about 2 mm (0·1 in) from the nib tip, with the curved end actually touching the nib. As you slide on the reservoir feel the tension with your thumb and fingers. If the reservoir is difficult to slide on it may be too tight. A tight reservoir will push the tines of the nib so they may actually cross over. Slide the reservoir off and slightly open the two side lugs (if this is difficult, use the dull side of a knife blade in the angle of the lugs to open them slightly). Now slide on again. The reservoir should should slide on easily but be tight enough to hold on to the pen. Hold the pen up to the light to check that the rounded tip of the reservoir is actually touching the nib. If it is not, then slide the

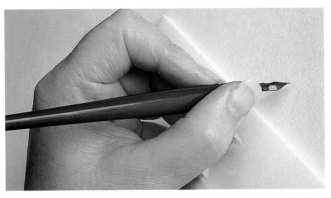

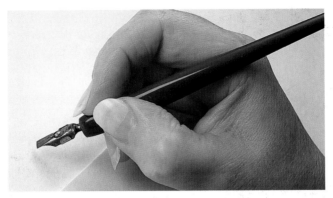

Holding your pen: on the left, for left-handers and on the right, for right-handers. Notice the slightly different grips.

Slide the slip-on reservoir underneath the nib, checking that the side lugs are not too loose or too tight. The rounded tip of the reservoir should touch the nib to feed the ink successfully to the end of the nib.

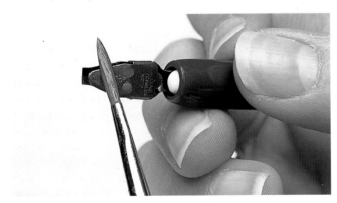

Filling a pen with ink: stroke the brush lightly on the side or underneath of the reservoir

reservoir off again and bend it to a sharper angle and try again. If the reservoir is pressing so much on the nib that it is pushing the tines of the nib apart, then slide it off again and bend it so that the angle is less sharp.

At first it may seem very fiddly to get a reservoir to stay on the nib and do its job properly, but it is worth persevering. If the reservoir is too tight or too loose then the ink will not flow well, and you will have difficulty in writing good letters. Before long you will feel automatically whether the reservoir needs adjusting as you slide it on to the nib.

Holding the pen

For right-handers, try to hold your pen in a conventional grip, that is about 1·5–2 cm (0·6–0·75 in) from the tip, and between the thumb and middle finger, with the forefinger sitting on the top for control. For best effect, rather than letting the pen rest in the v-shape between your thumb and forefinger, hold it so that it rests on your knuckle. When you write at a sloping board the pen will then be almost horizontal and so give you more control over the ink flow. (See page 6 for left-handers).

Filling a calligraphy pen with ink

There are two ways in which the nib should be charged with ink. The preferred way is to use a cheap paintbrush. Dip this in the ink and then stroke it along the side or underneath of the nib. Ink will collect between the nib and the reservoir. Alternatively you can do what it says

on the packet – dip the pen into ink. As you remove the pen from the ink, though, there will usually be a blob of ink on the top of the nib which will make the first letter clumsy, so gently shake the pen and then stroke the top of the nib on the side of the ink bottle, or wipe it on a folded piece of paper kitchen towel. Remember – dip, shake (very gently), stroke and wipe.

At first, when you are using a wide nib, you may be surprised at how many times you need to re-charge your pen. As you progress and start to use narrower nibs, though, your pen will need to be filled less often and thus the flow of writing will not be interrupted so much.

Getting the pen to write

Before you try to make thick strokes, move the pen backwards and forwards along the thinnest part of the nib to get the ink flowing, then make the thicker strokes. Ink will quickly dry on the nib tip, so start to write as soon as you can after charging the nib with ink.

If it takes longer than you think for the nib to start to write it may be that the shellac coating on a new nib is preventing the ink from flowing. Run the nib under warm water to dissolve the shellac, wipe dry on a piece of paper kitchen towel and reassemble the pen. It sometimes helps as well to moisten your finger with saliva and move the nib back and forwards on this to break the surface tension.

If the pen still does not write, then the ink may be too thick. Decant a little into another container and add some drops of water. Rinse out your pen and re-charge with this dilute solution.

Sharpening a nib

The best letters in calligraphy are those where the thin parts of the letter-forms are as thin as a whisker, and the thicker parts have really sharp and crisp edges. Sometimes, no matter how proficient you are, your letters will not be like this because the tip of your nib is, or has become, blunt. Occasionally even new nibs are manufactured with a dull edge and will need to be sharpened.

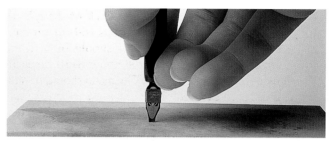

Start sharpening a nib by making sure the tip is straight by holding the nib in a vertical position and stroking it 8–10 times on a sharpening stone.

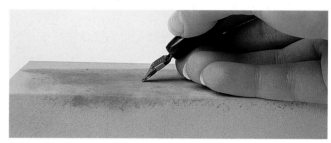

Hold a wide nib at an angle of 45°, or a narrower one at an angle of 30°, and stroke the top of the nib about 8–10 times in one direction.

To remove any metal burs, stroke both corners and the underneath of the nib on the stone, and then check the nib tip is shiny and sharp.

To sharpen your nib you will need a sharpening stone. The best sharpening stones are fine Arkansas stones which are available from specialist suppliers or tool shops. The stones are so milky white that they are almost translucent and should be smooth to touch. You do not need a very big stone, just one which is large enough to stroke a nib along (5 cm/2 in).

With the nib held firmly in the pen holder, and the pen held vertically, stroke the very tip of the nib on the Arkansas stone for 8–10 strokes. This ensures that the nib tip is straight.

Now turn the nib over so that the back of the nib (the top) is resting on the stone. If the nib is wide maintain an angle of about 45°; narrower nibs should be held at a lower angle of 30°. Stroke the nib about 8–10 times and then look at the nib tip carefully. The metal should be shiny where is has been exposed by the sharpening process, and it should be even across the whole of the tip. Try not to twist the nib in any way while you sharpen, otherwise one side of each tine will be sharper than the other.

There may be some metal burs on the nib, so before you write, gently stroke the corners and the underneath of the nib a couple of times on the stone to remove them.

Now write with the pen. Your letters should be crisp and sharp. If the nib catches in the paper, it may be too sharp, so dull the tip a little by stroking it along the very tip as in stage one.

After some use nibs do get blunter, so try to remember to re-sharpen them before a writing session if they have been used a lot. I generally sharpen nibs of the pens I am using before each writing session, but then I do like to use very sharp nibs.

Other pens and writing tools

A calligraphy dip pen with interchangeable nibs is not the only type of pen which can be used. Almost anything which can make thick and thin strokes or even a mark on paper can be used for calligraphy.

Double pencils

Many people start calligraphy with double pencils, which are simply two pencils taped together so that the tips are at the same height for right-handers, and the left pencil tip about 0·5 cm (¼ in) lower than the right for left-handers. Double pencils are very easy to move around on the writing surface and there is no problem of messy ink. Even experienced calligraphers will often use double pencils to work out the flourishes of large letters in a piece of work. Tape two felt tip pens together for a more formal effect. For notices you can shade in the spaces between the lines drawn with the pens.

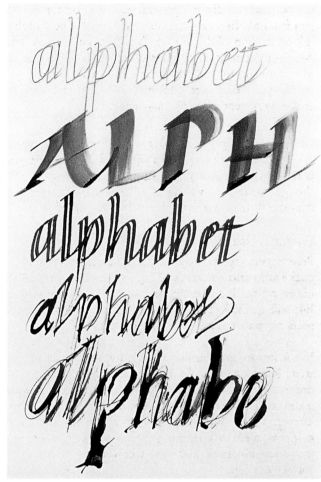

Letters made with double pencils, a balsa wood pen, an automatic pen, a ruling pen and a drinks can pen (aluminium can pen).

Balsa wood and cardboard

Very cheap pens can be made from a sheet of balsa wood which is at least 2 mm (0·1 in) thick, or even cardboard from a cereal packet. To make a balsa wood pen see page 80. Left-handers can cut a left-oblique tip. You can use a cardboard pen straightaway, although you will find that a new one is needed whenever it gets a bit soggy.

Dip the balsa wood pen or cardboard into a saucer of ink or paint and then write. For variations you can dip each side in a different colour for a variegated effect, or slice out a notch or two in the writing end for letters which will then have two or three strokes.

Automatic and Coit pens

These are available from specialist suppliers, and consist of a fold of metal or two pieces of metal plates coming together so that they form a broad-edged tip. Both types of pen come in a variety of widths and some have notches in the tips for multiple lines. Cut a tiny piece of sponge to push in between the two blades of automatic pens to act as a reservoir.

Ruling pens and aluminium can pens

Ruling pens can be obtained from specialist suppliers or can be found in technical drawing sets. When the blade is placed on its side it has the effect of a broad-edged nib. When used at the tip it forms a monoline letter. It is easy to make an aluminium can pen. Use the metal from the sides of a fizzy drink or soda can. With a pair of scissors carefully cut out a rounded triangle which is about 2 cm (0·8 in) wide at the base. Gently fold the triangle in half and push the widest part into a stick cut from a bamboo cane or a dried plant stalk from the garden. Either feed the ink into the pen or dip it into a saucer of paint. You may find that the pen splutters and sprays ink a little – this adds to the effect of the lively letter-forms.

Taking care of your pens

Calligraphy pens will last a long time if you take care of them. At the end of each writing session they should be taken apart and washed in warm water, but remember to put the plug in the sink beforehand to avoid losing reservoirs or nibs down the waste! Use an old toothbrush to remove caked-on ink. Dry the penholder, nibs and reservoirs on paper kitchen towel or cloth rag and either reassemble or store in a safe container.

Left-handers

Some of the best calligraphy and lettering in the world is done by people who are left-handed – this should be an inspiration and encouragement for those left-handers starting calligraphy.

It is possible to use right-handers' straight-cut nibs and twist your wrist to the left to achieve the correct pen angle, but you must have a very flexible wrist to do this. Most left-handers find that a pen with a left-oblique tip makes writing more comfortable and satisfactory, and involves less hand-twisting.

Holding your pen in a slightly different way will help (see page 3). It is important to be able to see your letter-forms, so a grip where your fingers are about 3 cm (1·2 in) away from the nib tip, and slightly rotating your hand to the left so that you are resting more on the side of your hand, should achieve this.

It will be very difficult for you to make the best letters, and not smudge where you have just written, if you hold your pen in an over-the-top grip, and learning calligraphy may be a good opportunity for you to try another writing position.

Setting up your board slightly differently from that of right-handers may also help. See the photographs on page 11.

Ink and paint

There are many different inks and paints which can be used for calligraphy, but not all of them are suitable for use with a broad-edged nib. Calligraphers need an ink which is opaque, so that the guidelines do not show through, but which is not so thick that it does not flow through the pen easily. Avoid any calligraphy ink which is waterproof as it contains shellac which will clog the nib. Fountain pen ink is ideal for fountain pens, but it can be a little thin and watery for calligraphy dip pens. The pencil guidelines may show through and the pigment in the ink collects at the base of the letters. Choose a calligraphy ink which is dense in the bottle; if it is too thick, you can always add a couple of drops of water to dilute it a little.

Sticks of Chinese and Japanese ink are often suitable for calligraphers' use as they are well pigmented and can be diluted to the consistency of your choice. With most stick inks available in the West, you get what you pay for, although most are perfectly satisfactory. With an ink

stick you will need an inkstone. This is usually made of slate, with a slightly roughened depression in the centre. Put about 10–12 drops of water in this depression and push the ink stick back and forwards. Gradually clear water will darken to grey and then black. Decant the ink into a small container and scrub the inkstone with an old toothbrush and water before you dry it on paper kitchen towel. To maintain the consistency of one batch of ink, count the number of drops of water used, and note the time spent grinding.

Gouache is a paint, like watercolour, but it has a chalk base added to increase its opacity; tubes are usually larger than those for watercolours. Before computers, designers used gouache to add colour to their work, which was not usually required to be permanent. For this reason avoid tubes of designer's gouache as it is unlikely to keep the strength of colour. Artist's gouache does have greater permanence. It is possible now to buy tubes of calligraphy gouache. This has been developed especially for scribes, and not only has the pigment been ground particularly finely to pass through a dip pen, but the strength of colour in the tube is greater, and so is the permanency.

Squeeze about 1 cm (½ in) of gouache from the tube into a palette or white saucer, first wiping away any excess clear gum. Add drops of water and stir with an old paintbrush until all the paint has mixed and it is the consistency of thin, runny cream. The paint should now flow easily through a broad-edged nib, and also cover any faint pencil guidelines. You can dilute the paint more if you wish to create watery-looking letter-forms, but the guidelines will show through, and the pigment will probably collect at the bottom of the strokes. See pages 108–109 for mixing colours.

Paper

Almost any uncoated paper can be used for calligraphy, while coated paper is used by printers. The paper in this book is coated and so the ink stays right on the surface and does not sink in. It is not suitable for calligraphy because the surface is too shiny and it does not have any 'tooth'. Uncoated paper is best suited to calligraphy and

it is sized, so that the ink does not spread as it would on blotting paper.

For practice, photocopying paper is often perfectly satisfactory, and if you use 70 gsm weight of paper (see page 8) you can often see the guidelines for the height of letters beneath the paper you are using if they have been drawn on a key sheet. This also saves you drawing lines on every sheet. Layout paper, which is about 45 gsm in weight, is also very good for starting out and for planning pieces. It, too, is slightly transparent, so you can see guidelines on the paper underneath which again will save you drawing them out each time.

For best pieces, though, you will no doubt choose to use a writing surface which is superior quality and looks and feels better than photocopying paper.

There are three key points to remember about paper:

- First, the surface of the paper affects the letter-forms. The paper you should usually choose is smooth, or Hot Pressed (or HP) paper. This means that after the paper has been manufactured it is passed through heated rollers, which, similar in effect to a domestic steam iron, push down all the fibres to create a flat surface. Photocopying paper is Hot Pressed.

If the paper is passed through cold rollers, not hot rollers, it is called Not or Cold Pressed. This surface is not as smooth as Hot Pressed and it is often used by watercolour artists.

If the paper is left to dry just as it after after being made, with no pressure on the fibres at all, these will stand proud of the surface and this Rough paper has a very uneven surface.

Letters written on Hot Pressed paper will generally have the smoothest outlines and crispest letter-forms. Those on Not, will have more jagged edges, and a sharp pen nib may catch in the fibres. A Rough surface will make letter-forms with very uneven edges and it is sometimes very difficult to write on paper with this surface. Using an automatic pen, or similar wide pen,

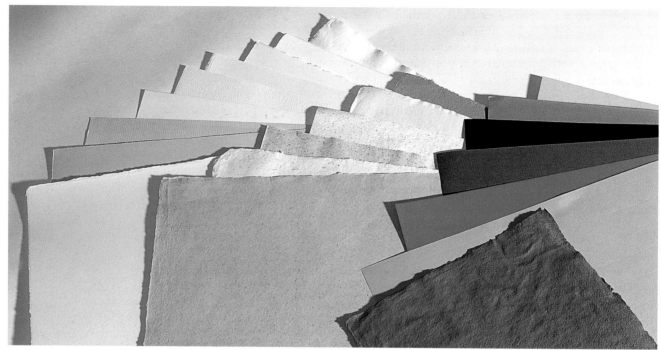

A variety of papers. Most are suitable for broad-edged pen calligraphy, but some require further treatment.
The fan starting at the centre and spreading left: Hand-made Not, Fabriano 5, Arches Aquarelle HP, Saunders Waterford HP, Saunders Waterford Not, Zerkall, Tre Kronor, Rives BFK (also available in white and cream), Banks' Bond. Centre fan: Hand-made papers – ash, dyed yellow, with tea fragments, with banana fragments, with water algae, brown. Right fan: Canson Mi Teintes yellow, Fabriano Ingres green, Tre Kronor black, Canson Mi Teintes grey, Canson Mi Teintes red, Fabriano Ingres grey, Hand-made brown Rough.

or a very fine nib may make for a more satisfactory outcome, although the edges of the letters will still not be smooth.

- Although the weight of paper does not necessarily affect the letter-forms, a paper which is heavier is often easier to work on because, if you make a mistake, there is more paper which can be removed with the error. With thinner sheets of paper, an erasure may actually make a hole in the paper.

In most countries paper is categorized by its weight, expressed in terms of grammes per square metre or gsm (gm^2). Photocopying paper is usually 70–80 gsm; 150 gsm paper is a good weight of paper on which to start writing out your best pieces. Later you may choose even heavier weight paper, perhaps up to 300 gsm or heavier.

- If paper is made by hand using a frame and deckle, the tiny fibres making up the sheet are in all directions. In machine-made paper the manufacturing process, though, gradually shakes the fibres so that most of them lie in one orientation. This is called the grain direction. You will have experienced grain direction if you have ever tried to tear a coupon out of a newspaper as the paper tears much more easily one way (the grain direction) than it does the other, where the edge will be quite uneven (see page 10).

For most of your pieces you will not have worry about grain direction, unless you want to tear it. However, if you want to use paper in a book, or fold the paper, then the grain direction needs to be parallel to the fold or tear.

Grain direction is much easier to detect than you may think. You can tear the paper, as with a newspaper

coupon, to see which gives the smooth, and which gives the jagged sides, or you can bend the whole sheet of paper over – it will bend over much more easily with the grain direction. Or you can moisten about 5 cm (2 inches) along the two sides of a corner; the water will make the side with grain direction go wavy. Lastly if you feel each edge of the paper, with the thumbs and first fingers of both hands about 10 cm (4 in) apart, and gently bend the paper, there will be more 'give' along the grain direction.

As soon as you have determined the grain direction, mark it with a faint pencil arrow so that you do not have to find it again.

Handling and storing paper

Get used to handling paper carefully as some sheets may cost quite a bit of money. When carrying sheets of paper to use, hold them in both hands with the sheets loosely bent. It is best, if you have the space, to store sheets of paper flat, rather than rolled in a tube. If you do have to keep paper rolled, you will need to allow some time for the paper to lose its curl before you can use it. Rolling it the other way and then allowing it to lie flat for some hours, maybe even a day or two, will usually work.

Keeping paper flat under the bed, or on top of a wardrobe will be good for the paper, but do not forget that it is there! Buy paper to use it, not just to store, or to save until your lettering improves. Many people find that their letters actually improve when they use good quality paper.

Sloping board

It is much more comfortable to spend time on your letters if you use a board which slopes. This keeps your back straight and should help you to relax your shoulders and writing arm. In addition a sloping board means that you have control over the ink coming out of your pen. If you write on a flat surface, then ink falls out of your pen by gravity; when writing at a slope your pen will be almost horizontal so ink will only come out when you apply pressure and flex the nib as you write. Aim to rest your board at an angle of about 45°.

Small and large letters on Hot Pressed, Not (Cold Pressed) and Rough papers.

Any non-flexible board will do – ply, MDF, or solid wood. These boards can rest in your lap and be propped up against the edge of the table or you may prefer to buy a sloping board which is usually covered in a wipe clean surface with a support which will allow you to adjust the angle. It is better to work at as large a board as you, and your storage, can cope with. Many people start with a board about A3 (297 mm × 420 mm/12 × 16 in) in size, and within about six months wish they had chosen larger.

Whatever the board is made of, you should pad it so that it is more comfortable for writing. A couple of sheets of white blotting paper taped to the board will give a sympathetic cushion.

Protect your work by having a guard sheet (a sheet of paper, taped across the lower part of your board). To gauge the height of this, adjust your board as if you were to write at it, with a pencil in your hand. Most people find that it is most comfortable if their writing hand is just below, or about the same height, as their shoulder. Make a mark on your blotting paper at this point. Tape the guard sheet about 2·5 cm (1 in) below this mark. (See pages 6 and 11 for left-handers.)

Rather than your hand moving to the right and left, up and down, the paper on which you are writing slides behind the guard sheet and it is this that moves, so that your hand stays at the same comfortable position. This means that you should not tape your writing paper to your board.

Other useful tools

When practising your letters, and for best pieces, you will need to rule guidelines, so a straight edge and pencil are essential. Drawing fine lines is possible only with a very sharply pointed pencil; those with a hard lead are the best as they keep their points longest. I use 4H pencils, which are then sharpened to a good point, or automatic pencils with a 4H lead. Although you may have a 30 cm (12 in) ruler, investing in a longer ruler, or, preferably a T-square or set square, will mean that you can draw longer lines and ensure that the lines are straight and parallel. An inexpensive rolling ruler device is useful for short lines,

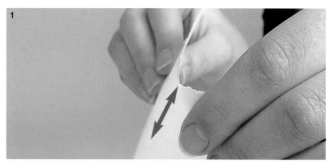

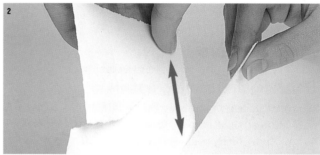

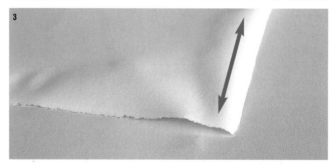

Determining grain direction. **1** Bending a short length of paper between fingers and thumbs. **2** Tearing paper (note that the previous tear in the paper at right angles to this one does not tear in a straight line). **3** Moistening paper (the short paper fibres are relaxed by the moisture and the edge of the paper is beginning to curl under in the direction of the long grain). **4** Bending a whole sheet of paper. In each case, the grain direction is parallel to the 'give'.

Setting up a sloping board: – for left-handers, – for right-handers.

Your hand stays at the same comfortable level and so the writing paper should not be attached to the board by clips or sticky tape but be moved up and down and to the right and left to maintain this position.

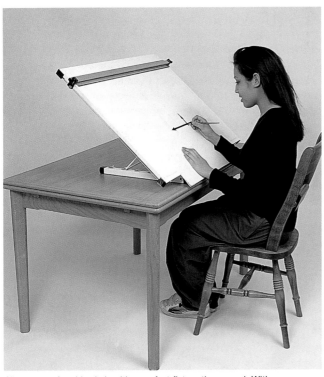

Sit on a comfortable chair with your feet flat on the ground. With your sloping board at an angle of about 45°, your writing hand should be a little lower than the height of your shoulder, so adjust the paper you are writing on up and down and to the right and left so that it stays at this comfortable level.

although they do not always make lines which are parallel. A straight edge or set square, either made of metal or with metal edges, will assist you when you are cutting paper with a sharp knife.

A set or two of dividers (similar to sets of compasses but with points at the ends of both arms) will help you to mark out guidelines for writing letters more easily. See page 113 for this.

Gradually you will collect together items of equipment which will be useful to you. This will probably include scissors, a soft eraser (one which has a very narrow edge is the most useful, see page 118), paper glue, Magic or masking tape, a sharp knife and so on. Keeping all this together in a box or plastic container will ensure that you always know where to lay your hands on what you need.

02 writing calligraphic letters

This section will show you how to write the four main historical alphabet styles, which will give you many variations for calligraphy. All the letters in these alphabet styles are written with a broad-edged nib which makes the characteristic thicks and thins in calligraphy. Wider nibs will produce larger letters (see opposite).

These letters are derived from historical lettering styles in manuscripts. For each of the four styles, the historical example is considered first and set in its context and then the exemplar letters are shown as an alphabet and in their family groups (see opposite).

Pen nib angle

Holding the nib at a particular angle to a horizontal guideline changes the shape of the letters, so it is important to make sure that you note the angle for each alphabet. See below for how much difference even a small change in the pen angle makes.

To help you maintain that angle, mark it out on your practice sheet, using a protractor, and draw parallel lines with a sharp pencil at this angle across your paper. Match up your pen nib to the angle as you make the letter-shapes. To save time draw these lines with a fine-pointed pen and place this sheet under your practice paper. Then use lay-out paper for writing and you will be able to see these lines through the practice sheet.

Separate strokes

When writing normally with a modern ball point or fibre tip pen, you can easily move the pen around so that it will write while being pushed in all directions. Pushing a calligraphy pen around like this is not possible because the nib resists being pushed upwards or to the left against its width. The result could be a splatter of ink spots.

It is for this reason that letters in calligraphy are made by lifting the pen nib between writing separate strokes.

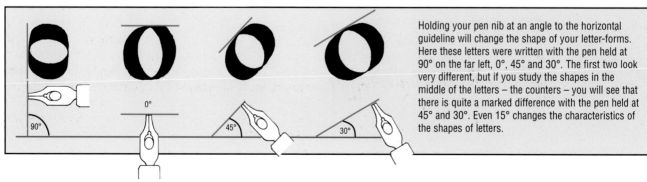

Holding your pen nib at an angle to the horizontal guideline will change the shape of your letter-forms. Here these letters were written with the pen held at 90° on the far left, 0°, 45° and 30°. The first two look very different, but if you study the shapes in the middle of the letters – the counters – you will see that there is quite a marked difference with the pen held at 45° and 30°. Even 15° changes the characteristics of the shapes of letters.

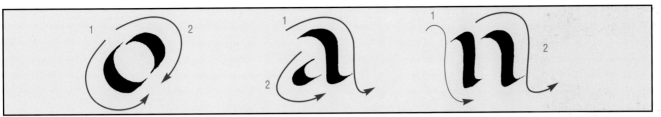

Calligraphic letters are made by writing separate strokes and lifting the pen between each one. For the letters shown on the following pages, note where the first stroke starts, follow the arrow around and lift the pen into the next position to make the second, and successive strokes.

Clearly the letter *i* is usually a simple downstroke, with the pen nib lifted to make the dot, if it is a minuscule (lower case, or small) letter. The letter *o* also has a pen lift. First the pen nib is moved towards the left and downwards along the curve; the pen is then lifted, and the second stroke completes the curve to the right and downwards.

Writing letters in calligraphy is much slower than normal handwriting because of the pen lifts and separate strokes, however this helps you to concentrate on the shape of the letter. Try not to write the letters too quickly when you start out in calligraphy, you can always speed up a little when you are sure of the letter-shape.

Heights of letters

The heights of letters in calligraphy relate to the width of the pen nib being used. A wider nib will make larger letters and a narrower nib smaller letters. To determine the height of letters appropriate to the pen nib you are using, turn it sideways so that it is horizontal and make a series of little steps which just touch one another and do not overlap.

For the Foundational Hand (English Caroline Minuscule) the x-height is 4 nib widths, the heights of ascenders and descenders 7 in all, and majuscules 6·5.

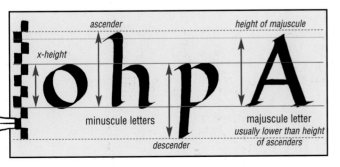

The body of the letter is called the x-height, because this is the height of a minuscule (lower case or small) letter *x*. The parts of the letter which go up, the ascenders – as on *b, h, k* – extend beyond the x-height, so too do the descenders – as on *p, q, y* – the parts of the letters which go down. The 'body' of these letters is still the x-height.

Note the x-height, and heights of other letters, in the pink key features box for each alphabet.

Family groups

It would seem obvious when practising letters to start with the letter *a* and work your way through the alphabet. To make quickest progress, though, it is better to divide the letters into families, where similar strokes are used. For the four alphabets in this book, the alphabet is shown for reference on the left-hand side; on the right, the letters are grouped according to their stroke-sequence families. Use these pages as a guide for your practice.

Sit up straight!

Practising letters and writing out best pieces can create a lot of tension in your hand, arm and shoulder. To help to prevent pain make sure that you always sit at a table and chair of a height where your feet are flat on the floor and the board is not too high or low, so that you are not stretching or crouching over your work. Try not to grip your pen so hard that it creates tightness in your hand. About every half hour or so, get up from your board and arch your back. Extend your arms and flex and reflex your fingers. Shrug your shoulders and circle them. Stretch backwards and forwards and let your arms and shoulders relax completely. Doing this will help to relieve tension and should help to prevent pain.

Angled Pen Uncials

Historical background

The tiny island of Lindisfarne, or Holy Island, is situated in a remote part of the United Kingdom, in the north-east of England, off the shores of Northumbria. It is isolated from the mainland twice a day by the high tide and it was on this island that the monks buried their beloved abbot-bishop, St Cuthbert, in AD687. This was not to be his final resting place, though, as Viking raids meant that the monks left Lindisfarne in 875 and carried his coffin around with them until the site of Durham Cathedral was revealed to them by God in 995.

St Cuthbert was probably the most venerated saint in England until Thomas Becket was murdered by the four knights in Canterbury Cathedral in 1170. People travelled from far and wide to pray at Cuthbert's tomb and ask for his blessing. He was a saintly man, who, as the Venerable Bede writes, had a particular affinity for animals and birds.

When his coffin was opened in 1899, a tiny book, the Gospel of St John, shown below, was found wrapped amongst other treasures. The script in this, the St Cuthbert Gospel of St John (or Stonyhurst Gospel), has been identified as seventh century and as having been written in Northumbria. It is in a bold writing style, but the letters are tiny – not more than a couple of millimetres high (just over 0·1 in). The letters are wide and generous; not narrow and pinched. This is a majuscule hand, there are no minuscules, although some of the majuscule strokes do extend above and below the lines for x-height. If you want to mark the beginning of a sentence with a capital letter, then use a nib two sizes larger than the one for the rest of the letters, or use a different colour.

The Gospel of St John was particularly important to early Anglo-Saxon saints like St Cuthbert. The word of God governed and guided their lives of holiness, devotion and preaching the Gospel, and the beginning lines of St John of 'In the beginning was the Word...and the Word was God' had particular significance.
British Library. Loan Ms 74, f. 27. Reproduced by kind permission.

a b c d e

f g h i j k

l m n o p

q r s t u

v w x y z

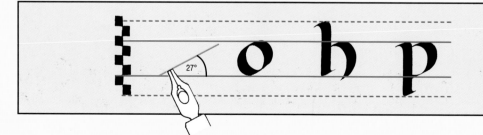

x-height – 3·5 nib widths
ascenders – 5·5 nib widths
descenders – 5·5 nib widths
nib angle – 27°
shape of the letter *o* – round
slant of the letters – upright

letters which start with a downstroke

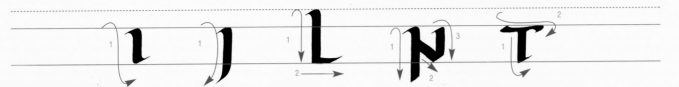

letters which start with a downstroke and then arch

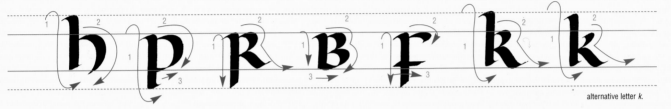

alternative letter *k*.

letters based on the letter *o*

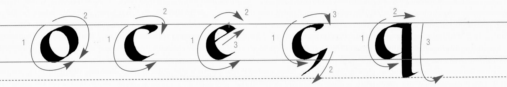

diagonal letters

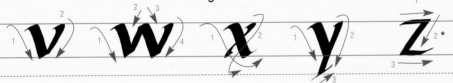

* flatten the nib to 0° for the second, diagonal stroke

letters which start with a round stroke to the left

letters which do not fit these families

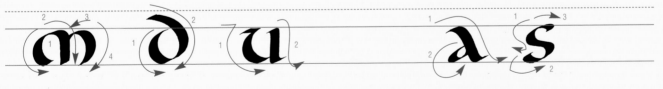

ampersand punctuation numerals

O SLeep!

O GeNTLe sLeep;

NATURE'S SOFT NURSe,

how have I FRIGHTed Thee,

THAT Thou NO MORe WILT WEIGH

MINE EYELIDS DOWN

AND STEEP MY SENSES

IN FORGETFULNESS?

WHY RATHER,

SLeeP

LIEST Thou IN SMOKY CRIBS,

UPON UNEASY PALLETS

STRETCHING THEe,

AND hushed

WITH BUZZING NIGHT FLIES

TO THY SLUMBER,

THAN IN The

PERFUM'D CHAMBERS OF THE GREAT,

UNDER THE CANOPIES

OF COSTLY STATE,

AND LULL'D WITH SOUND

OF SWEETEST MELODY?

Common errors

Entry and exit strokes too exaggerated.

Cross bar too curvy – let the pen make the stroke.

Bottom stroke too curvy – let the pen make the shape.

First stroke not long enough, and bowl too large, making an unbalanced letter.

First stroke too curvy and top and bottom strokes pulled in too much.

Arch-shape too tight and narrow, it should be round and open, like the *o*.

Third stroke joining the downstroke pushed up too much, making an ugly join.

Bowl of the letter too large, leaving little room for the tail.

Bowl again too large, and downstroke not quite long enough.

Crossbar should sit on the line, and top stroke should be a flatter curve.

Top stroke pulled in and down too much, should be a flatter curve.

Top stroke pulled in and joining stroke too far down, making the bowl too large.

Second stroke started too far to the right, making the letter look as if it is falling over.

Second stroke pulled down too much, it should be flatter as it meets the downstroke.

First stroke not curved enough and sags, making an ugly letter.

Opposite: Uncials can be effective with various quotations from prose and poetry. Although Irish in atmosphere, do not think that they can be used only for Celtic words or pieces with a 'top-o'-the-morning' feel.

and these few precepts in thy memory

Look thou character. give thy thoughts no tongue;

nor any unproportion'd thought his act:

be thou familiar, but by no means vulgar;

Spacing

Once you are comfortable with the shape, number of strokes and their direction in this and the following alphabet styles, you will soon want to combine those letters into words.

Spacing between letters

The spacing between letters in historical manuscripts is often much closer than would be expected nowadays. Look at that in the Ramsey Psalter (page 23), the inter-letter spacing does not relate very much to the spacing within the letters. However today's scribes seek to relate the spaces *within* letters to the spaces *between* them. This is easy to see with straight-sided letters:

Vertical lines drawn from the centre of each of the three downward strokes in the letter *m* indicate where the letter *i* should start, and this again indicates the space to leave between the letter *i* and the first stroke of the letter *n*, and then the second stroke of the letter *n* and the letter *t*.

When round letters are introduced, the same principle applies, although they look as though they are spaced slightly closer together to allow for the visual impact of the curve of the letter:

Vertical lines drawn from the centre of each of the three downward strokes in the letter *m* indicate where the letter *o* should start, and the second curve of the letter *o* indicates the space to leave between this letter and the first stroke of the letter *n*, and then the second stroke of the letter *n* indicates the spacing between this letter and the last letter *o*.

The same principle applies with diagonal letters:

As with all letters, but particularly so with diagonal letters, the negative and positive spaces have to be taken into account when thinking about spacing.

Although this may seem rather complicated at first, spacing will become almost automatic with practice, and soon you, like the best calligraphers, may come to regard a bad space worse than a bad letter!

Spacing between words

As the space between letters relates to the space within the letters, so the space between words relates to the letters themselves. Writing styles where the letters are narrower have less space between words, and in the same way writing styles which are more generous have a wider space left between the words. It all relates to the letter *o* of the alphabet you are writing.

Spacing between lines

Conventionally, the spacing between lines should allow for the ascenders to ascend to their correct height and the descenders descend to theirs. In the following section on English Caroline Minuscule (Foundational Hand; see pages 22–27) the ascenders extend for three nib widths above the top line for x-height and the descenders similarly three nib widths below the bottom line for x-height, and so the space between lines for this writing style should be at least six nib widths, although seven will ensure that if an ascender and a descender are on a crash course then they will not actually collide and make an ugly clash. Following the same principle, the space between lines for Gothic Black Letter (see pages 30–35) should be at least three nib widths (four for comfort), between Italic (see pages 36–41) ten nib widths (eleven for comfort) and between Uncials (see pages 14–19) five nib widths (six to be sure of no clashes).

In the case of majuscule alphabets where there are no ascenders or descenders, such as Roman Capitals, it is possible to space the lines much more closely together, as illustrated below. These letters will still be legible with only the minimum of space between lines, and often can be read with lines actually touching one another.

These are the conventional spaces between lines, but your piece, or the words, may not suit so much space in the design. If so, write out the words and lines in rough and then move them to the right or left so that the *g* of one line does not collide with the *h* on the following line, for example. Trying to contrive a way whereby the descenders and ascenders intertwine rarely solves the problem; more often than not it draws attention to an unresolved design difficulty.

Serifs

Serifs are the shapes made by the pen at the tops and bottoms of letters. If you look at the historical manuscript of the Ramsey Psalter on page 23 you can see a number of different serifs used in the same writing style. They range from simple curves as entry and exit serifs (which have been used on three of the exemplar alphabets in this chapter), wedge serifs which are a thicker stroke to the right before making the downstroke and club serifs

Simple entry and exit strokes made with a slight movement of the pen.

Straight serifs made with the pen held at the same angle (30°) as for the script.

Straight serifs made with the pen at a flatter angle (10°).

Hairline serifs made with the pen held at 0° to the horizontal.

Beak serifs as on historical scripts – they may look a little dated now.

Move the pen in a curve to the right before the downstroke, and then at the base take the pen to the left as shown before finishing the serif.

which are a thickening of part of the downstroke. It is probably better to decide on one style of serif and use that for the beginnings and endings of all letters in the style you are writing. Start with the simplest and then, if you wish, and when you are ready, progress to those which take more construction.

Spacing between lines for minuscules needs to allow for potential clashes of ascenders and descenders, but majuscules can be written with very little space between lines and still be legible. Here a contrast is made by starting the quotation from Shakespeare's *The Tempest* vertically, in minuscules with gold over-writing and in a different size nib.

THE ISLE IS FULL OF NOISES,
SOUNDS, AND SWEET AIRS, THAT GIVE DELIGHT AND HURT NOT.
SOMETIMES A THOUSAND TWANGLING INSTRUMENTS
WILL HUM ABOUT MINE EARS; AND SOMETIMES VOICES
THAT, IF I HAD THEN WAKED AFTER LONG SLEEP,
WILL MAKE ME SLEEP AGAIN; AND THEN, IN DREAMING,
THE CLOUDS METHOUGHT WOULD OPEN, AND SHOW RICHES
READY TO DROP UPON ME, THAT WHEN I WAKED
I CRIED TO DREAM AGAIN.

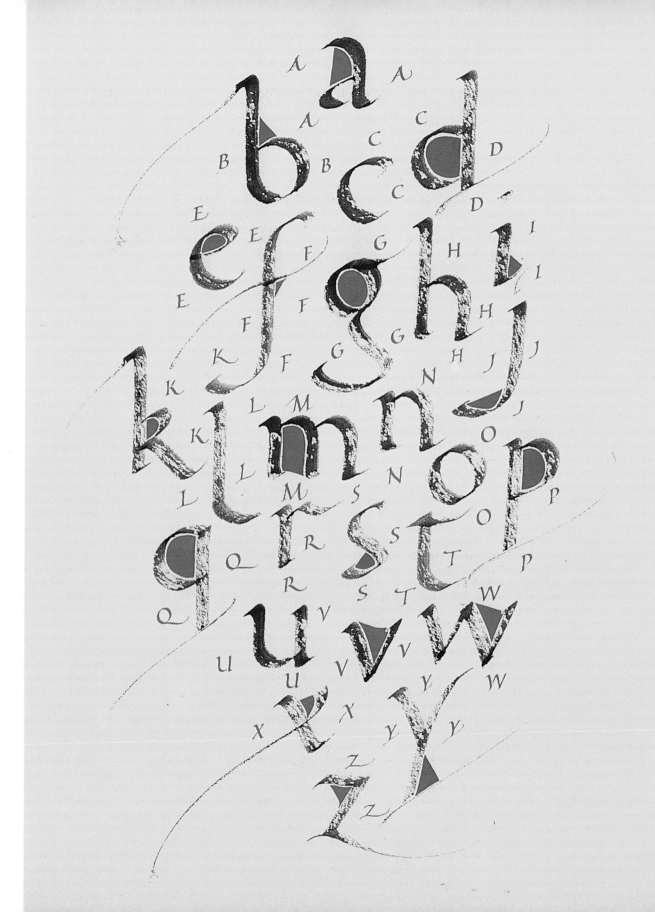

English Caroline Minuscule (Round Hand) or Foundational Hand

Historical background

Charlemagne (AD742–814) was a great reformer. Under his rule schools were established, Christianity, agriculture, commerce, literature and the arts promoted and the legal, judicial and military systems reformed. For calligraphers, though, it is perhaps the writing style which developed during his reign which is the most important.

Caroline Minuscule is clear, easy to read, and not too difficult to write. There are pronounced ascenders and descenders to the letters, and, unlike Uncials, this is a minuscule script, with capital letters used for headings and the beginnings of sentences. During Charlemagne's time, books became easier to deal with because all sorts of clues were introduced to help you to find your way around. Beginnings of sections were marked by *incipits* ('this is the beginning…'), large capital letters denoted

headings, and endings were marked by *explicits* (the end).

When Caroline Minuscule crossed over to England certain subtle changes occurred. The x-height increased and, proportionately, the heights of ascenders and descenders decreased. The letters were still based on a round letter *o*, and legibility was the key – it is very easy to identify each letter in this manuscript. There are wide spaces between the lines and the letters look gracious and grand.

Edward Johnston (AD1872–1944) did much to influence the revival of calligraphy early in the twentieth century. He studied many mediæval manuscripts and as a result of this work developed the Foundational Hand which was based closely on Caroline Minuscule letter-forms found in the Ramsey Psalter (illustrated below).

A psalter is a book of the Psalms, which was one of the most important books from the Bible in the mediæval Church. All 150 Psalms would be recited each week.
British Library. Harley MS 2904, f. 122v Reproduced by kind permission.

a b c d e

f g h i j k

l m n o p

q r s t u

v w x y z

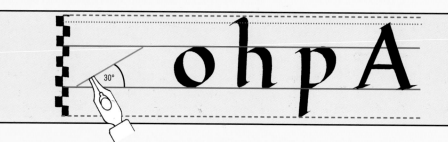

x-height – 4 nib widths
ascenders – 7 nib widths
descenders – 7 nib widths
majuscules – 6–6·5 nib widths
nib angle – 30°
shape of the letter *o* – round
slant of the letters – upright

letters which start with a downstroke

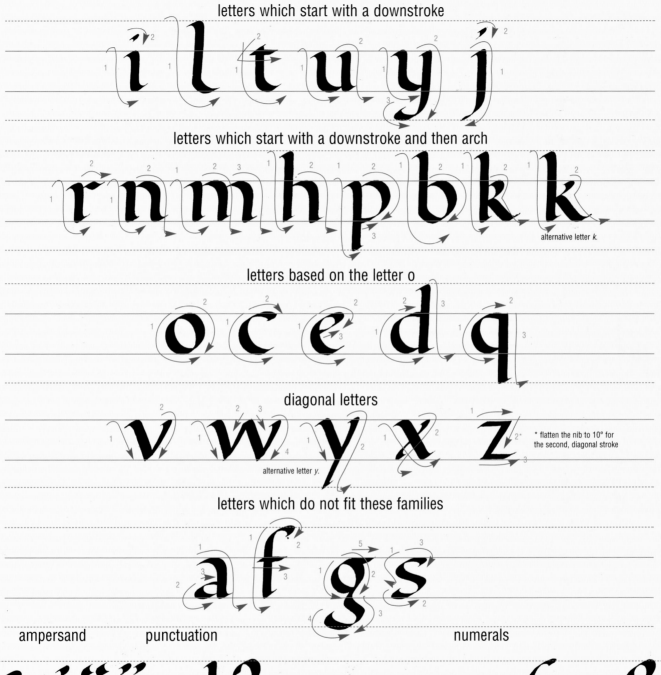

letters which start with a downstroke and then arch

alternative letter *k*.

letters based on the letter o

diagonal letters

* flatten the nib to 10° for the second, diagonal stroke

alternative letter *y*.

letters which do not fit these families

ampersand punctuation numerals

Layout and design

Once you have satisfactorily combined letters, words and phrases in one or two alphabet styles you will soon be wanting to write out pieces. More guidance is given on pages 103–06, but here are some basic pointers on layout and design. Seeing words set in type which suddenly come to life and have so much more meaning when written out calligraphically can be so rewarding, perhaps some words larger than others, some written in a different alphabet style, or some in colour.

It is often best to settle for a simpler design when starting out – sometimes ambition is in advance of skill. The most important point to remember is that calligraphy needs room to breathe so allow generous margins. If you have to work to a particular size, such as the dimensions of a special picture frame, then choose a smaller nib width so that there is a lot of space around your work and it does not look too crowded.

The conventional margins for a broadsheet are that the top space is slightly less than that for the two sides, and the base has more space, but unconventional margins often make for an arresting piece. A piece where the lines are aligned left is easier to write out than a centred, lines written around the centre or an aligned right piece. If you do choose a centred design then make sure that the piece has a spine, otherwise it will not hang together – the eye should be led through the writing.

Combining letters with paintings and drawings, and including colour needs a sense of balance. Try to think of each of these as separate elements, and then to reduce them to only three per piece at first. A coloured background, vari-coloured letters, different sized letters, more than two scripts and full colour painting will mean that the eye cannot focus on any one aspect, and so will probably not focus on any. (See also Chapter 7, page 102.)

Aligned left pieces are easiest to write out.

Centred pieces often draw the eye to the shape the lines make.

Lines written around a central line need to be balanced and have a spine.

Avoid placing the lines so that there is no spine. Also try to avoid diagonals.

Bottom heavy pieces do not always work. Top heavy are often even worse!

Lettering of varying sizes can be eye-catching.

A vertical line adds contrast, and means that lines can be written against it as a left margin.

Ensure you have wide enough margins and avoid too many changes in pen sizes.

Common errors

Many people start calligraphy by learning English Caroline Minuscule (Foundational Hand) and as, at that time, they are not skilled calligraphers they may use incorrect letter-forms which can easily become established, and which can only be eradicated with difficulty. Here are some common faults:

i — Entry and exit strokes too curly. Dot also a bit exaggerated.

i — Entry and exit strokes too curly as is the downstroke.

t — Downstroke starts too far up giving ugly triangular crossbar.

t — Crossbar too wavy – let the pen do the work.

u — First stroke pushed up too far, giving wrong shape at base.

u — As before, but letter also too narrow.

r — Second stroke starts too far down and also too hooked.

r — As before also too exaggerated, it should be a gentle curve.

n — Second stroke starts too far down.

n — As before, but arch is wrong shape – should be rounded.

m — Base exit strokes too curly.

a — First stroke starts too far to right – incorrect arch-shape.

a — As before, bowl a little too large.

a — First stroke correct, bowl too large.

o — Wrong shape strokes giving a narrow letter slanting forwards.

e — Bowl too large. It should join first stroke about halfway.

v — First stroke too steep so letter looks as if falling forwards.

v — First stroke too gentle so letter looks as if falling backwards.

x — Both strokes too curly. Only the entry and exit strokes curve.

z — Nib angle for the second diagonal stroke should be at 10°.

s — First stroke too curly, second and third strokes too hooked.

s — Wrong curve on first stroke giving a top-heavy letter.

s — As before, but a bottom-heavy letter.

c — Second stroke too hooked, closing in the letter.

f — Crossbar and foot too curly, last stroke too hooked.

g — Bowl too small, tail not pulled in to left enough giving wrong shape.

g — Bowl a little large, tail not pulled in to left enough giving wrong shape.

g — Bowl right size, tail too far to left at start.

g — Correct shape letter and also symmetrical, which is what it should be.

h — Entry and exit strokes too curly. Second stroke a little low.

p — Third stroke too curly, should be flatter. Entry and exit stroke too curly.

d — Second stroke too curved, making ugly combination of this and downstroke.

The friends thou hast, and their adoption tried,

Grapple them to thy soul with hoops of steel;

But do not dull thy palm with entertainment

Of each new-hatch'd, unfledg'd comrade.

roman capitals

A B C D E
F G H I J K
L M N O P
Q R S T U
V W X Y Z*

* flatten the nib to 10° for the
second, diagonal stroke

~ steepen the nib to 60° for
this stroke.

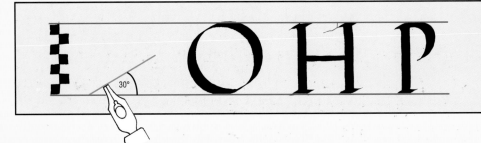

x-height – 7 nib widths
(reduce this to 6–6·5 nib widths if
combining with English Caroline
Minuscule)
nib angle – 30°
shape of the letter *O* – round
slant of the letters – upright

Roman Capitals

Roman Capitals are a majestic form of letter which are particularly grand when they are used for carved inscriptions on buildings and commemorative plaques. The Romans had a deep understanding of proportion and sizing, and perhaps the best examples of Roman Capitals are on Trajan's Column in Rome, which was put up in AD114 to celebrate Trajan's victories over the Dacians.

These majuscule letters work well when used on their own, or combined with other alphabet styles. They are often used as the capital letters with English Caroline Minuscule (Round Hand or Foundational Hand).

Family groups

Most Roman Capitals can be grouped into families which have similar widths. The exceptions are I, which is a straight line, W which is the width of two slightly narrower Vs, and M, which is a V with slightly splayed supporting strokes.

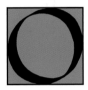

The letter O can be encased within a square.

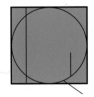

Other round letter-forms – (O), C, D, G and Q take their roundness from this letter and width from the square.

Symmetrical letters – A, H, M, N, T, U, V, X, Y, Z are as wide as three-quarters of this square.

Asymmetrical letters – B, E, F, J, K, L, P, R, S are as wide as half of this square.

Common errors

A
Letter too wide, first stroke at wrong angle.

B
Top bowl too large.

C
Curve not round enough, and leans forward.

D
Letter too narrow, and ugly join at base.

E
Top stroke too long.

K
Third stroke does not start from the downstroke.

M
First and fourth strokes too splayed.

P
Bowl too large and narrow.

R
Bowl too small and third stroke does not start from the downstroke.

S
First stroke too curvy and second and third strokes should be flatter.

T
Crossbar too curvy – let the pen do the work.

U
First stroke joins the downstroke too high up.

W
V-shapes too narrow and ugly cross-over join.

X
First stroke too upright, second stroke too curvy.

Z
Second diagonal stroke not at 10°, making a weak letter.

TALL NETTLES COVER UP, AS THEY HAVE DONE
THESE MANY SPRINGS, THE RUSTY HARROW, THE PLOUGH
LONG WORN OUT, AND THE ROLLER MADE OF STONE:
ONLY THE ELM BUTT TOPS THE NETTLES NOW.

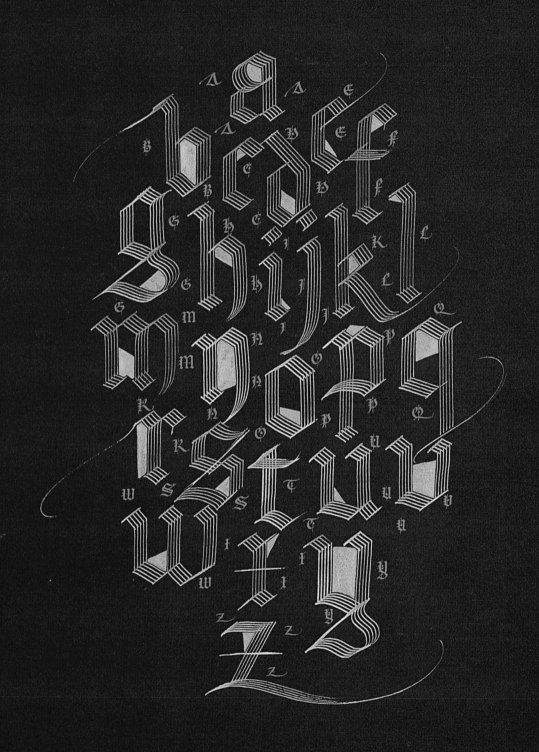

Gothic Black Letter

Historical background

Books of Hours were the mediæval best-sellers. People were becoming increasingly literate and there was a demand for a book which enabled the devout to study selected Biblical texts and follow the prayers of the canonical hours (*matins, lauds, prime, terce, sext, nones, vespers* and *compline*) in a simplified form at home. Included in a Book of Hours was also a calendar showing the main saints days, with the important ones written in red (from which we get red letter days), and Christmas Day, Epiphany, etc. written in gold (golden days). The Penitential Psalms, Gradual Psalms, the Office of the Dead, Suffrages (prayers asking for a saint's intercession), and the Little Office of the Virgin could all be in a Book of Hours.

Because they were for private use, most Books of Hours were able to be held in the hand, and the pages were cut from very thin skin. To include all the information necessary the writing was usually quite small, and the illumination and use of colour depended on the budget of the person who commissioned the book.

In the Bedford Hours, commissioned by John, Duke of Bedford, money seems to have been no object – judging by its size and the amount of gold and colour used. The script is a regular, tight Gothic Black Letter, characterized by having very few curved strokes. It is sometimes difficult to identify individual letters, and thus no surprise that the hair-line stroke over the letter *i*, which eventually became a dot was introduced during this period. Unusually for calligraphic hands, majuscules are larger than the full height of ascenders, and are characterized by infilling with diamonds, flicks and vertical hairlines.

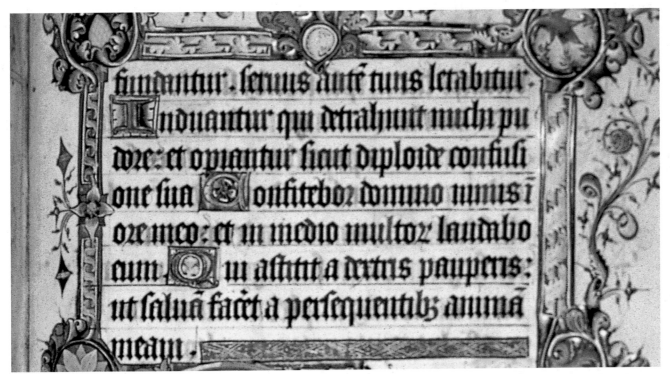

The Bedford Hours commemorated the marriage, on 13th May 1423, of John of Lancaster, Duke of Bedford (and elder of the two surviving brothers of Henry V of England) and Anne of Burgundy, one of the younger sisters of Philip, Duke of Burgundy. It was a political match to cement the Treaty of Amiens.
British Library. Additional MS 42131, f. 183. Reproduced by kind permission.

gothic black letter minuscules

a b c d e

f g h i j k

l m n o p

q r s t u

v w x y z

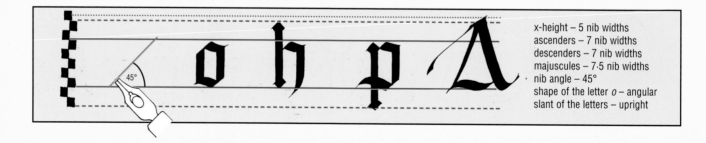

x-height – 5 nib widths
ascenders – 7 nib widths
descenders – 7 nib widths
majuscules – 7·5 nib widths
nib angle – 45°
shape of the letter *o* – angular
slant of the letters – upright

letters which start with a downstroke

i l j t

letters which start with a downstroke and then arch

r n m b p h k

letters based on the letter *o*

o c e g q d a

simplified form of *a*

letters based on the letter *v*

u y v w

letters which do not fit these families

use the left-hand corner of the nib for this stroke.

a f s t z

* flatten the nib to 10° for the second, diagonal stroke

ampersand punctuation numerals

t '.,.:; !?- 0123456789

gothic black letter majuscules

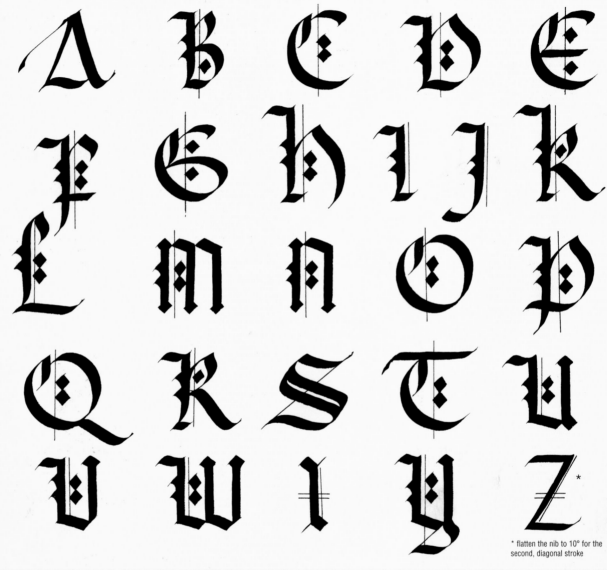

* flatten the nib to 10° for the
second, diagonal stroke

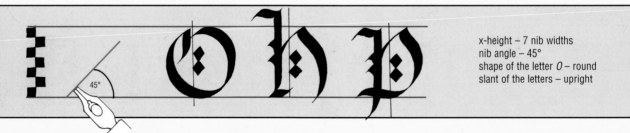

x-height – 7 nib widths
nib angle – 45°
shape of the letter *O* – round
slant of the letters – upright

Gothic Black Letter spacing

Because the script is so regular and even, the commonest problem is one of spacing, although it is easier to understand the principle of spaces *within* letters being equal to the space *between* letters in this writing style. The letters can be written with very little space between the strokes, and thus very little space between the letters, or with more space between them, which will widen the space between letters too, and make for a more open hand.

The letters here have very little white space between the strokes and so, to keep the spacing even, the same amount of white space has been left between the letters themselves. This can make legibility difficult but is true to the original mediæval forms.

Fishtail serifs

Letters in this script often have a forked end to the downstroke of ascenders and descenders. It may take a little practice to achieve this. The first stroke is made with a slight curve from the right and then the downstroke. Making sure that there is sufficient ink in the pen, use the left-hand corner of the nib to pull the ink up and out to complete the shape. For descenders make the downstroke and then use the left-hand corner of the nib to pull out a hairline to the right.

A fishtail serif is made in two strokes, first the downstroke, and then, with a fully charged pen (it sometimes helps to press down within the stroke itself to release some ink) use the left-hand corner of the nib to pull the ink into the fine fishtail.

Common errors

The second stroke is at too steep an angle making the join with the downstroke too low and the bowl too large.

The arch-shape is too round for this style, leaving a white space within the letter which will not match the rest of the letter-forms.

The letter starts too high, resulting in an ugly triangle for the crossbar. The letter *t* should always start just above the top guideline for x-height.

The tail curve on the right is too gentle and long, so the diagonal from the body of the letter to complete the shape is too shallow, making a very open letter.

Give every man thine ear, but few thy voice;

Take each man's censure, but reserve thy judgement.

Costly thy habit as thy purse can buy,

But not express'd in fancy; rich, not gaudy;

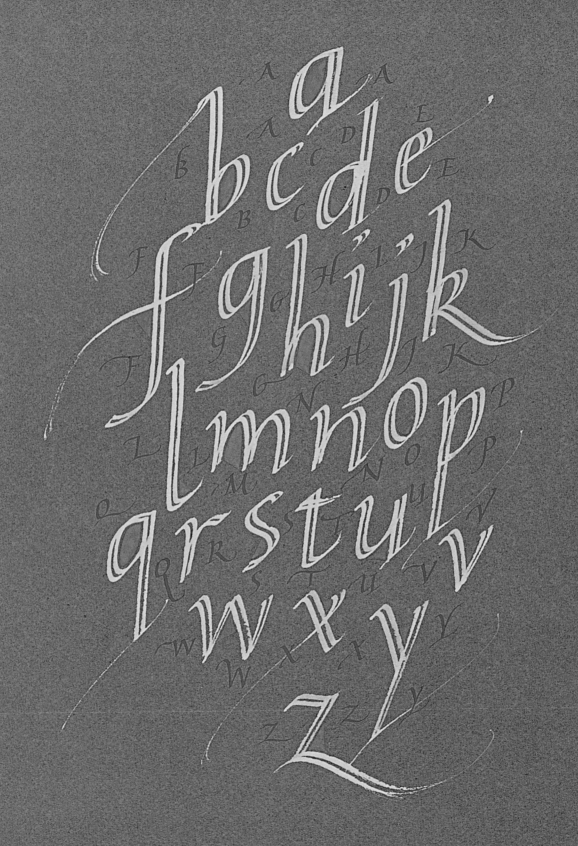

Italic

Historical background

It was Petrarch (1304–1374) who went back to those classical Caroline Minuscule letter-forms to develop a 'modern' style which became eventually Humanistic Minuscule. But it was Niccolò Niccoli who, by 1420, had developed from this style a more rapidly written or cursive script which became known as Italic. This style was adopted by the scribes of the Papal Chancery who embellished it even more, so from a form of handwriting, there came, by the second quarter of the fifteenth century, a high-grade book script, used in the most prestigious and grand books, and eventually Italic typefaces.

Three-quarters of a century later Ludivico degli Arrighi produced the first printed book on how to write – *La Operina,* published in Rome in 1522. He is regarded as being one of the most important writing masters of the time and worked for the Apostolic Chancery as well as producing luxury manuscripts for wealthy patrons.

It is surprising how a writing style developed in the fifteenth century looks so modern, and is often a script people wish to use for their own handwriting. It is characterized by an oval-shaped slanting letter *o*, and other letters such as *a, d, g, q,* and then *b, p, h,* etc. take their form from this. The narrower *o*-shape means that diagonal and arched letters are also less wide. Note particularly the springing arch form on letters *r, n, m, h, b* and *p.* Ascenders and descenders are high and lend themselves naturally to flourishing. The hand is particularly adaptable and is fast becoming one of the most popular calligraphic styles as both formal and informal pieces look elegant in this script.

This book was commissioned from Arrighi by an English diplomat, Geoffrey Chamber, probably during the second quarter of the sixteenth century, to present to King Henry VIII. It was painted and illuminated in lavish style by Attavante degli Attavanti who incorporated Henry's coat of arms on the first page.
British Library, Royal MS 12 C. viii., f.6. Reproduced by kind permission.

italic minuscules

a *b* *c* *d* *e*

f *g* *h* *i* *j* *k*

l *m* *n* *o* *p*

q *r* *s* *t* *u*

v *w* *x* *y* *z*

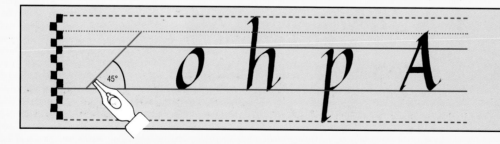

x-height – 5 nib widths
ascenders – 9 nib widths
descenders – 9 nib widths
majuscules – 7 nib widths
nib angle – 45°
shape of the letter *o* – oval
slant of the letters – 5–7°

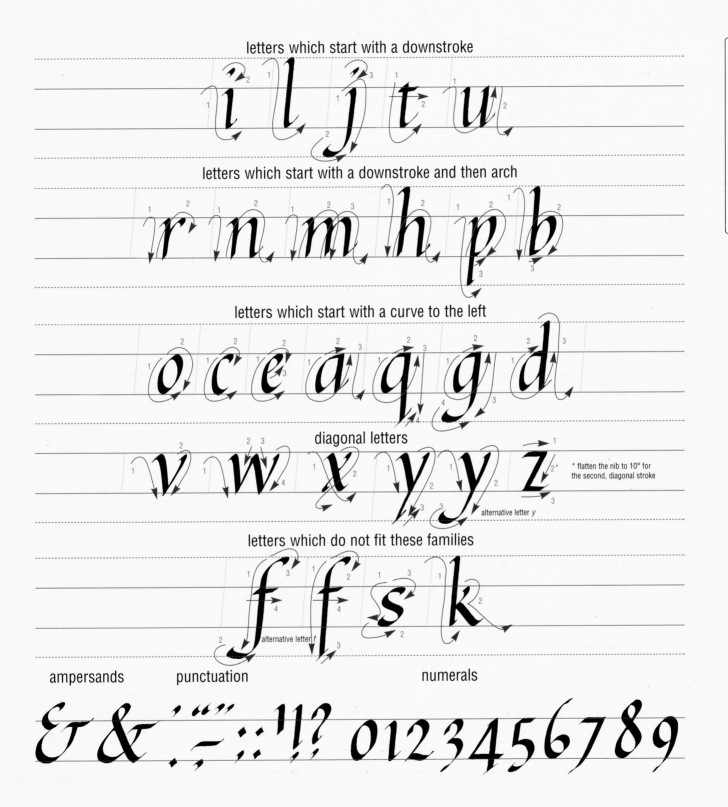

letters which start with a downstroke

letters which start with a downstroke and then arch

letters which start with a curve to the left

diagonal letters

* flatten the nib to 10° for the second, diagonal stroke

alternative letter *y*

letters which do not fit these families

alternative letter *f*

ampersands punctuation numerals

italic majuscules

A B C D E

F G H I J K

L M N O P

Q R S T U

V W X Y Z*

* flatten the nib to 10° for th
second, diagonal stroke.

~ steepen the nib to 60° for
this stroke.

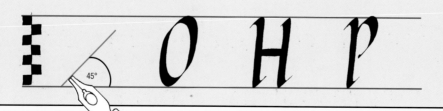

x-height – 7 nib widths
nib angle – 45°
shape of the letter O – oval
slant of the letters – 5–7°

Letter shapes

One of the key letters of this hand is the letter *a*. You should note particularly the shape of the bowl, which is a steep curve first to the left, which flattens slightly at the thickest part of the stroke, and then turns in a dull point, not a sharp one. This stroke is then continued right up to the top guideline for x-height. If you stop before then there will be a noticeable join between this stroke and the downstroke, whereas this junction should be smooth.

This then applies to related letters such as *d, g, q, u*.

In the same way, the upstroke making the arch for the letter *n* is pushed up from the base guideline for x-height, ensuring a smooth curve along the whole of the arch. This is then repeated in related letters *r, m, h, b, p*, and the looped *k*, if used.

To ensure a smooth join between the bowl of the letter *a* and the downstroke, push the curve right up to the top guideline for x-height. If you stop on the way you will invariably be able to see the join. Then complete the letter.

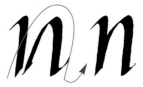

After making the first downstroke, start the second stroke, the arch, from the base guideline for x-height and push right up to the top line, starting to form the arch about half-way up the stroke. Let the pen dance lightly over the paper for this stroke as you are pushing it up against its width.

Common errors

Bowl pulls in to the right at the base.

Bowl turns at too sharp an angle at base.

The first stroke is not steep enough.

The strokes are too curvy.

The angle should be 10° for the diagonal.

The strokes are too curvy.

First stroke should push right up to top.

Arch should start from base guideline.

Third stroke should be flatter. Bad serlf on tail.

Wrong curves with a backwards counter.

Bowl too large, joins first stroke too far down.

The top and base strokes are too curvy.

Neither a borrower, nor a lender be;

For loan oft loses both itself and friend,

And borrowing dulls the edge of husbandry.

This above all: to thine own self be true.

Italic flourishes

Italic letters are ideal for flourishing. The cursive nature and feel of movement in the hand lend themselves to extended and exaggerated strokes. The key with flourishes, as with almost all calligraphic strokes is to let the pen do the work. The stroke itself forming the letter is therefore usually straight, and it is just the entry and exit strokes which flow with a slight curve into a flourish. Whatever the flourish, the letter itself should not be distorted so that it is illegible.

It is difficult to push a thick nib against its width to make a flourish and you may prefer to practise flourishes with a calligraphy felt tip pen or two pencils taped together.

Working out flourishes in a calligraphic piece is often best done with a pencil (see opposite). Using a smaller nib or a quill for the final writing makes flourishing less of a challenge.

The maxim 'flourish little but flourish well' is a good one to adopt. Too many flourishes can take away their impact. Flourishing at the beginnings of verses or paragraphs, and at selected places (preferably evenly) along the top line and bottom line of a piece usually work best. Try not to flourish the beginning of *every* line unless they are spaced far apart. Also remember that not every single ascender and descender needs to be flourished!

Examples of flourishes on majuscule Italic letters. These show simple flourishes which can be applied to other letters as well. For example, the extended stroke to the left on the letter *A* can also be used for the letters *B, D, E, F, H,* and so on. That on the letter *B* can be used on any letter with an upright – *D, E, F, H,* etc. The extended curve on the letter *P* could be used on the letter *F,* too. The letters which are most difficult to flourish are *C, O* and *S.* These letters can be written much larger, or even as separate strokes pulled slightly apart from one another, but none lend themselves to extensions of strokes without causing considerable distortion to its shape.

A B E G G H I I
K L M N P Q
R U V W X Y Z

Examples of flourishes on minuscule Italic letters. The flourishes shown here for the ascender of the letter *h* can be used too with any letter which has an ascender – *b, d, f, k, l,* etc. Those shown here for the descenders of letters *f* and *y* could also be applied perhaps to *g, j, p, q.*

Below: When working out flourishes for a piece of calligraphy, it is often easier to work in pencil. Here far too many flourishes were tried at first – a common problem. The final piece is more restrained and works better. The background was made by using very dilute calligrapher's gouache in vermilion and a mixed yellow ochre applied with a sponge. The lettering was written in red metallic calligrapher's gouache – not the easiest for flourishing!

But forth one wavelet, then another, curled;
Till the whole sunrise, not to be suppressed,
Rose, reddened, and its seething breast
Flickered in bounds, grew gold, then overflowed the world.

But forth one wavelet, then another, curled;
Till the whole sunrise, not to be suppressed,
Rose, reddened, and its seething breast
Flickered in bounds, grew gold, then overflowed the world.

03 greetings cards and bookmarks

One of the most agreeable aspects of any celebration is to receive greetings cards; if these have been hand-made then the occasion is made even more special. This chapter focuses on different ways of celebrating occasions in the form of greetings cards and bookmarks.

When starting out in calligraphy, the problem which often occurs is that you may have good ideas and lots of ways in which you could use your newly-found skills, but the technique may still be slightly wobbly. You could find yourself spending a lot of time cutting up coloured board and expensive paper and designing a most attractive card, and then messing the whole thing up by making a spelling mistake, or writing a couple of bad letters or even making an ink blot when writing on the card itself. The first few cards here look at ways in which you can avoid these sorts of annoying problems.

The first cards shown on the following pages involve writing a letter, a word, or a greeting on a piece of paper which is then attached to one or more backing papers or cards, which can be of matching or contrasting colours. This technique means that you can start making cards, bookmarks, and other pleasing objects very early in your calligraphic career. It also enables you to use and make many varied and decorative backgrounds to your own efforts.

Cards which use only one letter

For the cards opposite, white paper, 250 gsm in weight (see page 18), was used as the base for the card itself. The card should be substantial. If you are saving money by making your own cards, as well as giving something to someone which will delight them, do not skimp on the paper which makes the base card, otherwise it looks a little cheap. If you cannot obtain any heavy weight paper or card, then use a piece of paper which is four times the size you require for the finished card and fold it in half and then in half again, remembering that one fold should be on the left-hand side and the other along the top.

To make the textured background for these cards, cut a rectangle approximately A4 in size (about 30 × 20 cm/

It is best to cut all lines using a sharp knife and metal straight edge, rather than with scissors, as the lines must be sharp and accurate. Measure accurately with a 4H pencil sharpened to good point. Always mark measurements and draw lines on the underside of the card or paper. If you get into the habit of this then you will not always have to erase markings when you have finished as they will be hidden. A bone folder with a pointed tip is an invaluable tool for the projects in the following chapters. Use the point to score lines and then when you fold, run over that fold with the side of a bone folder to reinforce the crease. In the diagrams in the following chapters, a solid line is one which is cut, and a dashed line, one which is folded. Areas to be pasted are shown by parallel grey lines.

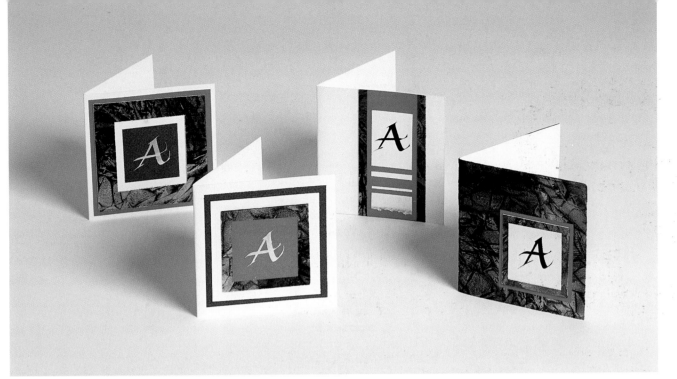

Personalized greetings cards for any occasion which contrast red, black, grey and white. The textured black and grey background is made by laying clingfilm (saran wrap) over an ink wash (see below).

12×8 in) from the base paper. This card does need to be of a good weight as you will be applying a wash. If the paper is not at least 200 gsm you will need to stretch it first (see page 112).

Now mix up some ordinary calligraphy ink with a little water; you may need to dilute it slightly. Then tear a wide strip of clingfilm (saran wrap) from the roll, bigger than

your sheet of paper, and put to one side as best you can. The ink should now be applied across the paper covering it completely, using a water-colour wash brush which is about 3 cm (1 in) thick. Alternatively an ordinary wide home decorating brush can be used. Immediately, place the clingfilm over the wet wash and then use the fingers of both hands to gently pull the film inwards so that it is creased. You can see almost at once the crackle effect that it will make, and may want to use your fingers to pull the clingfilm inwards in other areas.

Now let the wash dry completely before removing the film. For a less precise image, the film can be removed before the wash is dry; it then looks slightly blurred.

The cards shown above were designed as squares, but they work equally well as rectangles. It is not difficult to make your own envelopes to match these cards (see page 54), but if you choose not to, do make sure that your designed hand-made cards fit into standard sized envelopes.

To make a textured background, a dilute calligraphy ink wash is applied to heavy-weight paper or card. Immediately a wide strip of clingfilm (saran wrap) is laid over the top and then pulled in slightly with the fingers to make a crackle effect. This is then allowed to dry completely before the film is removed.

Each card here is 10 cm (4 in) square, so cut a piece which is 10 × 20 cm (4 × 8 in) from the 250 gsm white paper using a knife and metal straight edge on a cutting mat or old board and fold it in half. The card with a white *A* on a red background is made by cutting a square of grey card which is about 5 mm (0·2 in) smaller all round than the dimensions of the folded card. Cut a smaller piece of white card, and then a piece of the textured card which is again slightly smaller. Lastly, use dense white gouache to write the initial letter on red card. Space the letters some distance apart, then when you are happy with one of them cut it from the rest of the red card, making sure that the dimensions are in proportion to the other cut squares.

The card is finished by sticking square upon square (making sure they are in the right size order!) using paper glue or PVA. To ensure there are no paste marks on the front of the card itself, use the pages from old magazines or colour supplements (where the paper is shiny, and therefore coated – this means the printing ink should not come off). Place the item to be stuck face down on the magazine page and apply the glue all over; if you go over the edge it does not matter because it is only waste paper. Use a clean page for each pasting and throw the used pages immediately into a bin. It is not worthwhile trying

to be economical and save paper here because you will be sure to place a precious piece of paper, probably the piece where you have done a beautiful letter, right on top of a large dab of wet glue.

The card to the left in the illustration on page 45 is made by cutting a square 'window' from the middle of a square cut from the textured background which in turn has been pasted on to a red square slightly smaller than the card. A smaller square with an initial letter is then pasted on to the card set into this window. For the third card a black letter on a white rectangle, together with a few white strips was pasted on to red card and that then pasted on to a rectangle of the textured background. The textured background is used as the base of the fourth card, and squares of red card and the textured background form the base for a white square with a black letter.

You can experiment with different shapes, sizes and combinations of red, black and grey to make any number of individual and very different cards.

Bookmarks

The same idea can be applied to make bookmarks. Here the same weight white card is used as the base. Cut a

These bookmarks use the same design ideas as in the cards on the previous page. Because the initial letter is written on a separate piece of paper and pasted on afterwards it means that the best letter can be chosen, and the whole bookmark is not ruined if the letter-shape is not good or the pen makes a blot. Taking the pressure off in this way often means that the letter is a better one because you are more relaxed.

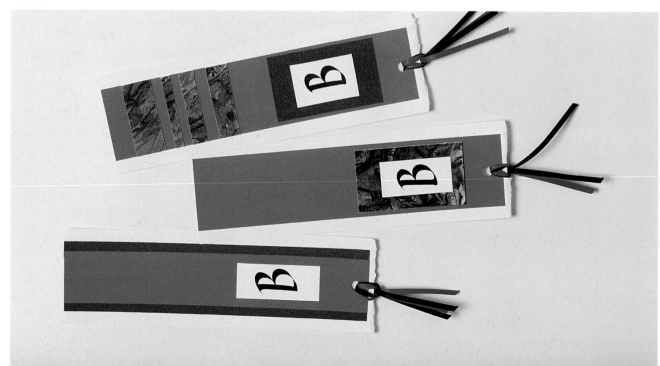

To make the tie on a bookmark, cut two 15 cm (6 in) lengths of matching narrow ribbon and fold them in half. Poke the loop through the punched hole in the bookmark and thread the ends through the loop. Pull the ends so that the loop tightens. You may need to adjust the ribbons so that the ends are even. Cut the ends at an angle to prevent fraying.

Cards which use a block of text

Although these cards may look a little daunting, because they contain a block of text rather than just one letter, the lettering is written out and then reduced using a photocopier. This often makes letters which you are not happy with at full size acceptable. It is also a great help if you are still using pens which are quite wide, because the letters are written with a wide pen and the photocopier does the rest. You can even replace some letters or amend spelling errors by pasting correct or better written letters over the errors.

rectangle with dimensions approximately 6 × 19·5 cm (2·5 × 7·5 in). Then cut narrower rectangles from red and grey card and strips from the textured card to decorate one of the bookmarks.

Once the rectangles and the initial letter have been pasted on to the base card and the glue has dried, identify the end to which you want to attach ribbons and turn the card over to the back. Measure and mark with a pencil dot the centre point which is about 1·5 cm (0·5 in) in from that end. Use a hole punch to make a neat hole. Cut two 15 cm (6 in) lengths of matching narrow ribbons and thread these through the hole.

Because these cards involve a lot of text, it is best to choose words which are not personalized. You can always add a coloured initial letter, or make the inside of the card more individual.

Using a wide nib, measure out the x-height for the alphabet you choose to use. These designs use Gothic Black Letter which makes a bold pattern. On a sheet of paper about A4 in size (approximately 30 × 21 cm/12 × 8 in), use a pencil to rule faint parallel lines for the x-height across the paper. Add lines for the slant of letters and nib angle if it helps you. If the lines are faint enough they will not show when you photocopy it.

These cards are made using a block of calligraphy reduced on a photocopier. Errors can be corrected, and large letters look better when they are reproduced at a smaller size. This is very helpful if you are not yet that confident about using a narrow nib. The reduced lettering can be reused any number of times.

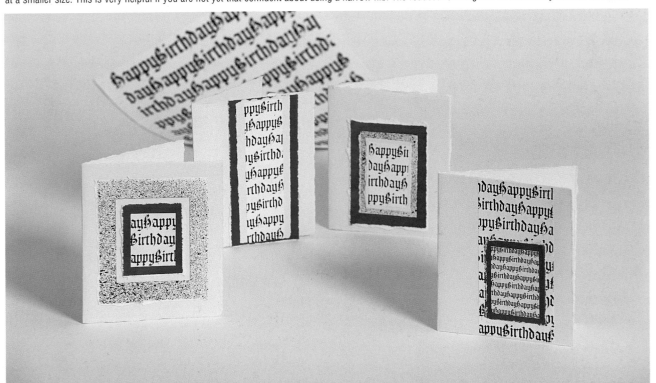

Use an old toothbrush to create a dense spray pattern and a textured background for cards and bookmarks.

Now use a dense black ink and write your message using the lines you have drawn. Do not leave any gaps between the words, keep the lettering even, and write on every other line, not worrying too much about ascenders and descenders clashing. Carry on from one line to the next even if you are in the middle of a word. You want to try to make each line different so that there is not too much of a repeating pattern. Start in the middle of a word if it looks as if a line is going to be similar to the one above.

Now, make the backgrounds. Choose a white card which is about 250 gsm in weight. Mix up some gouache to the consistency of thin, runny cream so that the colour matches, contrasts or tones with the colour you are planning to use for the card itself.

First cut a piece of paper which is about A4 in size and use a wide brush to paint an even dense wash all over the paper. If your paper is not 200 gsm in weight, you will need to stretch it (see page 112). Allow to dry.

Cut another A4 sheet of the same paper and lay it on a flat surface covered with sheets of newspaper. This process is messy so you, and where you are working, need to be protected. Use an old toothbrush and with the same mix of gouache, dip the brush into the paint. Use your finger, or a plastic ruler to spray the paint from the bristles, moving your finger towards you. (If you move your finger away from you then the paint sprays on you!) Experiment on the newspaper first. Sometimes the paint is too thick and the spray is uneven; sometimes the paint is too thin and the spray marks too large. When you are happy with the consistency of the spray, cover the paper with an even texture. Make sure that it is dense enough to be a good contrast. Allow to dry.

The edges to these cards and the decoration on them are made from a torn edge. If the paper is thick enough then this looks very effective. If it is thin, it can look cheap. You can tear paper along a ruler, and this gives quite a precise torn

To create a 'deckle' edge, either tear the paper along a ruler, or wet the paper by running a brush with water along the ruler, allow to soak in and then tear.

You can push sections of the wet paper in with your finger to make a good imitation of a 'deckle' edge.

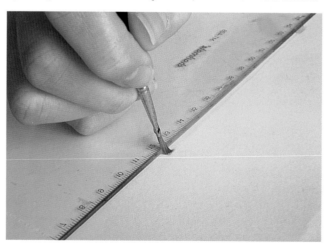

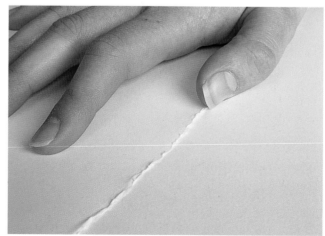

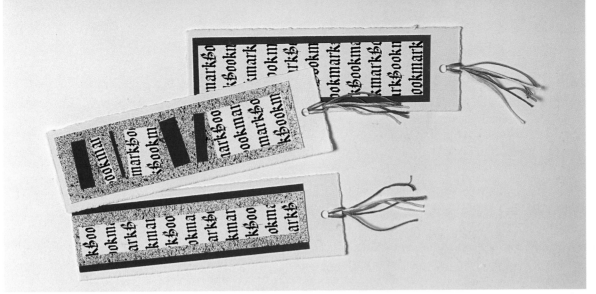

These bookmarks use reduced photocopies of large lettering cut into strips and mounted on to contrasting strips of coloured and splattered papers. The ties are made from embroidery silks in toning colours.

line. To create a more 'deckle' edge, then select a fine paintbrush, dip it in clean water, turn your straight edge on its back so that there is a gap between the edge and the paper, and place it along where you want the deckle to be. Run the brush along the straight edge for the length of the deckle. Allow the water to soak in (thicker papers will take longer), and then gently pull the paper apart along the wet strip. Push in sections of the paper along the wet strip and it will look even more like the 'deckle' edge of hand-made paper.

Now photocopy your sheets of lettering. Reduce the lettering by as much as you can, 50% if possible. Place this reduced lettering in the photocopier and reduce again. It may be possible to photocopy on to a coloured paper, but do ensure that this matches with your chosen colour scheme and does not introduce too many different elements into what is a simple design.

The cards shown on page 47 are rectangular, but they work just as well as squares. Use a similar weight of paper as before. Tear rectangles (or use the wet water method shown on page 48) which are approximately 22 × 14·5 cm (8·5 × 6 in) from your chosen base paper and fold in half. Now tear a rectangle which is about 7 × 9·5 cm (2·75 × 3·75 in) from the painted paper, another rectangle which is smaller all round by about 1 cm (0·4 in) from the splattered paper, and then another which is about 5 mm (0·2 in) from the base paper. Because photocopying paper is usually only about 70 gsm it is too lightweight to be torn effectively for this

design, and in any case you would not want your lettering to have torn edges, and a cut edge makes a good contrast. Cut a rectangle of the photocopy which is just a little smaller all round and paste one piece of paper on top of the other. It does not matter if the words do not start at the beginning, nor whether they are complete along the lines, the message is obvious as you read successive lines. The final pasted rectangles can be glued in the middle, as shown here, or to one side – both look effective.

Make another card by tearing the outer and cutting the inner edge from the splattered paper so that you have a window, and in this paste on to the card itself a torn rectangle of the coloured wash and a smaller rectangle of your photocopied message. Another alternative is to cut rectangular strips, here using the photocopy on to a strip of the card paper, and then paste this on to a strip of the coloured wash. The last design uses the smallest photocopied reduction as a rectangle pasted on to the coloured wash which is then in turn pasted on to a strip of the larger photocopy.

Bookmarks

The same idea applies to bookmarks. You can use the 'Happy Birthday' lettering, but if you take the time to write out 'Bookmark' in the same way as before and photocopy it, you will be able to make as many bookmarks as you could possibly want – always re-photocopying the original lettering when you need to.

The dimensions are the same as those given on page 47, and strips of coloured wash and splattered paint are cut in decreasing sizes, with a strip of lettering as the smallest. To liven up a bookmark, strips of the photocopying and the coloured wash can be placed at angles to one another as shown on page 49.

Cards which use geometric shapes

These cards, shown opposite, use geometric shapes as decoration, and if your hand is not very steady then these are ideal for you to try. Although the theme of these cards is for St Valentine's Day, they would work just as well for anniversaries using the same designs, or other celebrations using different designs.

Making a good heart-shape is not difficult. First use a pencil and straight edge to draw a vertical line on a piece of light-weight or tracing paper, and then draw half a heart. Ensure that there is a good lobe to the heart and that the line going to the tip is smooth and curvy. Fold the paper in half along the drawn vertical line. Using a pair of scissors, cut out your heart along the half-heart shape. Open out the fold and you will have a symmetrical heart. Use this as your template to draw hearts. Now make two more heart shapes so that you have small, medium and large heart templates.

On a piece of red card use the largest template to draw a large heart shape, and cut this out using scissors. Cut out a rectangle which is about 16×13.5 cm (6.5×5.25 in) from a piece of white or light-cream card which is about 250 gsm in weight (see page 44 for the weight of paper for cards). Fold the card in half. Mark the centre point along the top edge of the card and use a pencil and straight edge to mark out a rectangle which is about 4×8.5 cm (1.75×3.25 in). When you are sure that this rectangle is centred, use a fine-pointed, black pen and straight edge to go over the lines.

Mix up some red calligraphy gouache (vermilion works well) and use a medium size nib to write your message – 'Love always' – on layout paper. When you are happy with the words, mark the centre point of each word and cut it out. Place the cut-out red heart towards the top of this rectangle, and use a pencil to mark its lowest point faintly. Do not paste it on yet. Using a pencil and straight edge rule draw faint horizontal parallel lines below this point, using the available space. Mark the midpoints of these lines using the centre point already identified for the card.

Using tiny pieces of masking tape, attach the first word above where you are to write, aligning the centre point for the word with that on the card. Take a deep breath, charge your pen with gouache and write the word. Remove the taped word. Allow the paint to dry (or use a hairdryer to speed the process). Repeat this for the second word. Erase the pencil lines.

Now use paper glue or PVA to attach the red heart, ensuring that it is centred. Write your personal message inside or leave it blank for a mystery Valentine.

For the second card, using the same weight paper, cut a rectangle which is 21×13.5 cm (8.5×5.25 in) and fold it in half. Use a pencil and straight edge to mark out a vertical line which is 2.5 cm (1 in) from the left fold. Now mark horizontal lines which go from this marked line to the left fold which are 2.5 cm (1 in) apart. Make sure that these lines are parallel. Use a fine-pointed pen to mark in these lines.

Cut five 1 cm (0.4 in) squares from red card. Use the template for the smallest hearts to cut out five hearts from white paper. Use paper glue or PVA to attach these to the squares, setting them at an angle as shown. Now paste these into each corner. Practise writing the text and when you are happy with each word, cut it out. Draw three horizontal lines, using a pencil and straight edge. Use tiny strips of masking tape to attach the first word above where you are to write. Take a deep breath, charge your pen with red gouache and write the first word. Remove the exemplar word and allow the paint to dry. Then repeat until the message is written. Erase the pencil lines.

For the next card cut out a rectangle which is about 20×10 cm (8×4 in) and fold in half along the top. Using a pencil and straight edge measure a faint vertical line

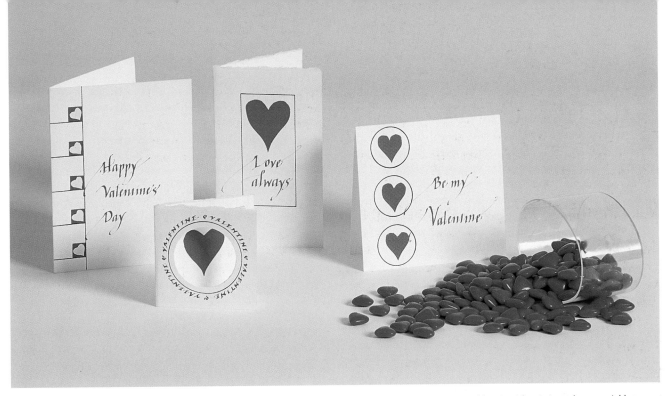

These Valentine's day (or anniversary) cards use fine-pointed black pens, straight edges and sets of compasses with cut-out hearts to make eye-catching greetings which will certainly attract the attention of your true love.

which is about 2·5 cm (1 in) from the left-hand side. To draw the circles use a set of compasses where the pencil point has been replaced by a fine-pointed pen or a ruling pen attachment. You can also draw round coins, but this is rarely as successful. Draw three circles which are an equal distance apart and where the centre point is based on the vertical pencil line.

Use the medium heart template to cut out three red hearts and paste one in the centre of each circle. Practise the writing as before, and, as described above, write your message on the card in red ink.

The last small card uses a circular cut out. From the base paper cut out a rectangle which is 14 × 7 cm (5·5 × 2·75 in) and fold it in half so that the fold is on the left. Using a pencil and straight edge, mark the centre point. Place the compass point here and describe a circle which has a radius of 4·5 cm (1·75 in). Replace the pencil point with a fine-pointed pen or ruling pen, and describe a circle which is 0·5 cm (0·2 in) larger in radius. Replace the pencil point and describe a circle which is a few mm (about 0·1 in) larger and describe a circle (you could draw

circles one and three at the same time). Use a sharp knife to cut out the innermost circle. Use the large heart template to cut out a red heart. Paste this on to the card beneath positioned in the centre of the cut-out.

Draw circles of the same radius as the largest circle on a piece of layout paper. Practise writing out the message until the lettering is evenly spaced. It is difficult to use your practice letters as a guide when writing in a circle, but the advantage is that spacing problems are not always so obvious. Use red gouache to write your message around the largest circle. Erase the pencil lines.

Cards as envelopes

All the cards shown on page 53 have the message written on the outside and are folded to make envelopes. They can be personalized by including the recipient's name as part of the lettering. Inside could be a longer message or a tiny flat gift. The weight of the paper for these cards does not need to be so heavy, as all are lined with a contrast paper.

For these cards you will need some medium-weight paper for the outside of the finished pieces, and some thinner paper, of a contrasting colour, for the lining. The first card is based on a square. Make the inside of the card first. On the contrast paper, using a sharp knife and metal straight edge cut out a square which has sides of 15 cm (6 in). Using a pencil and a straight edge, mark the diagonals, taking care that they cross exactly in the middle. Use this midpoint to mark with a pencil and straight edge another square which has sides of 10 cm (4 in) and is at right angles to the first.

Now using a sharp knife and metal straight edge cut out a square which is 14 cm (5·5 in) from the outside paper. Choose a nib size which is not too large and rule up guidelines for the x-height of your chosen script across the outside paper. Using gouache, write your message along every alternate line for x-height, leaving no spaces between the words and letting one word continue from line to line, avoiding any obvious patterns. When the ink is dry, paste the top paper to the contrast paper, making sure that the margins are equal all round. When the glue is dry, on the contrast paper inside the card, use a pointed bone folder and straight edge to score along the marked lines for the inside square. Now fold over opposite sides to make the card.

The next card is similar in idea but based on a circle. It is sometimes difficult to cut out a circle with an even edge using scissors or a knife. For these cards use compasses to mark the circle, but instead of having a point and a pencil lead, use two metal points (dividers) and score out the circle as you draw it with one of the points. The action actually cuts the shape from the paper and gives a slightly frayed edge and a very even circular form.

Again start with the contrast paper first. Score out a circle with a radius of 10 cm (4 in) using compasses with two metal points (dividers). From the centre, mark a square which has sides of 10 cm (4 in). Now score out a circle from the outer paper, which has a radius of 9·5 cm (3·8 in). Rule guidelines and write your message on the outside paper as before. Paste the outer paper to the contrast paper, and when dry score lines on the inside along the marked square. Fold over opposite sides.

The triangular card is also made from a circle. Score out a circle which has a radius of 6 cm (2·3 in) on the contrast paper. Draw a line across the centre using a pencil and straight edge. Mark a point which is 3 cm (1·15 in) from the centre, and draw a line at right angles to it from edge to edge. Now draw a line from the point where one end of this line hits the edge of the circle to where the diameter line across the circle meets the edge. Finally join this point to the other to make an equilateral triangle. Repeat this for the outer paper, but in this instance the circle should have a radius of 5·5 cm (2·2 in); the other dimensions remain the same.

Write your message on the outside as before, and when dry paste to the inner circle. Score along the triangle

Envelope cards: cut out the yellow shapes, score along the dashed lines. The first card is based on a square within a square, the second a square within a circle and the third an equilateral triangle within a circle.

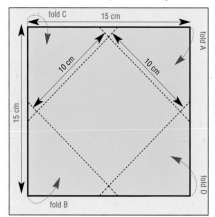
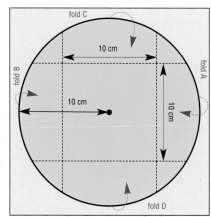
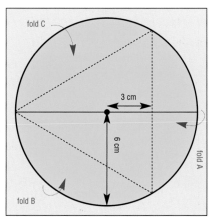

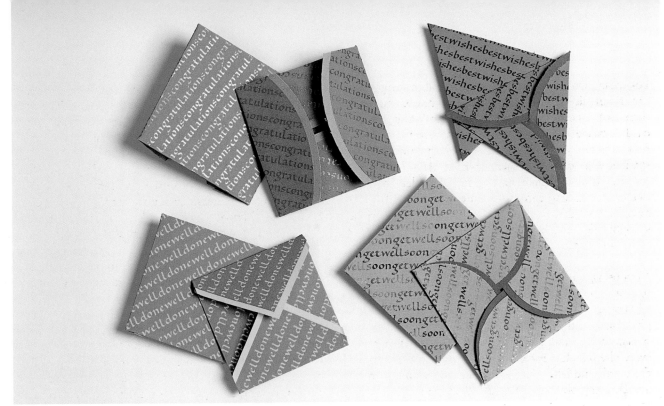

These cards all have the message written on the outside and, as each one is personal, you can include the recipient's name as part of the message. Inside you could write your name, or put in a tiny, flat (even precious) gift.

marked inside using a bone folder and straight edge and fold in the sides, tucking each one under as you go.

The last card uses a square and semi-circles. On the contrast paper mark a square which has sides of 10 cm (4 in). Mark the centre point of each side, and use this to score out semi-circles on the four sides. On the outside paper, also mark a square which is 10 cm (4 in), and then another which has sides of 9·5 cm (3·4 in) inside. Mark the centre point of each of these sides and use this mark to score out semi-circles with a radius of 5 cm (2 in) on each side.

Rule lines and write your message on the outer paper. The variegated effect in the lettering was achieved by using green and yellow gouache. Charge two brushes with one colour each and then feed a tiny amount into the pen as you write. You have to look carefully at each stroke as you write to ensure that there is a balance of colour. The paint mixes in the pen as you write, but you will sometimes have to engineer a colour change so that one is not more dominant. Try other colours, too.

Paste the outside to the inside, making sure that the edges of both squares are a good fit. Now score along the square on the inside of the card, and fold in each semi-circle in turn. The whirligig effect appears as you tuck in the sides.

For the fourth card, paste shape II (the outer) on to shape I (the inner) and then fold over the semi-circles in the order shown.

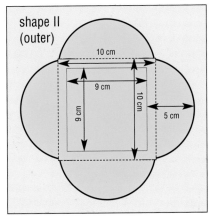

wraps, folds and boxes

The cards at the end of the last chapter could also be used as envelopes for other greetings cards. This chapter shows you how to make wraps, folds and boxes which are decorated with calligraphy, and could contain calligraphic gifts as well. As with the first cards in the previous section, the calligraphy for all of these projects can be pasted on after you have written the letter, name or words with which you are satisfied, so that your lettering does not spoil the rest of your handiwork.

Envelopes

The easiest way to make an envelope that will match a greetings card is to use a rectangle from the same sheet of paper. For the first envelope shown here measure the greetings card and add 1 cm (0·4 in) to the measurements to allow space for your card to slide in and out of the envelope. It is usual to allow a further 1·5 cm (0·6 in) to either side of these measurements for the side flaps, but if your greetings card is very small this may overwhelm the rest of the envelope, so adjust appropriately. The top flap is usually about 3–4 cm (1·25 –1·5 in) and the bottom flap is about three-quarters or two-thirds of the length of the card. However, here also you may need to adjust if your card is particularly large or small.

On a matching or contrasting piece of paper, which is not too heavyweight – not more than about, say, 150 gsm –

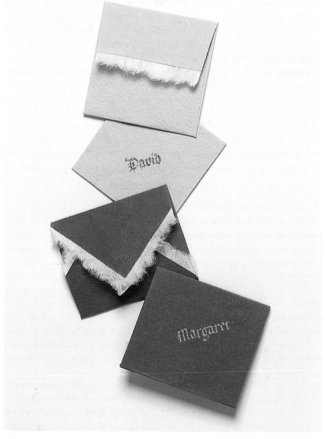

Two different envelopes, lined with hand-made paper with a pronounced deckle edge. The envelopes match the greetings cards within.

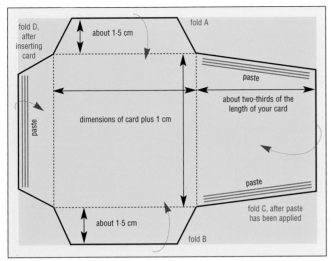

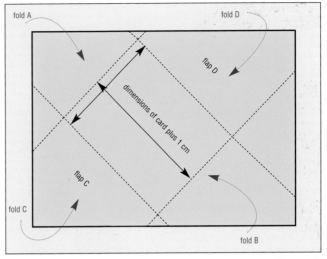

The envelope shape above can be adapted to suit any shaped card, but the one on the right is best for rectangular cards only. Fold along the dashed lines and cut along the solid lines.

draw out the dimensions of your card plus the extra 1 cm (0·4 in) top and side. Now mark out the side flaps, as shown above, tapering them slightly at each corner. Mark out the top and bottom flaps, again tapering them to the corners. Using a bone folder and a straight edge, score around the rectangle of the measurements of your card (plus the additional allowances). Cut out the envelope. Fold over the side flaps, and then run a line of glue along the side edges of the bottom flap, and fold it up. Press this flap down on to the side flaps and allow to dry. Slide the card into the envelope and close the top flap either using some glue, or with a little square of matching paper on which you have written an initial letter.

If you want to line this envelope, before you paste and seal, cut a strip of lining paper which is the same width as the card (plus), but 1 cm (0·4 in) longer than the length of the whole envelope. Paste the lining to the paper after you have cut it out, but before you score the folds, allow an overshoot of lining paper which is 0·5 cm (0·2 in) beyond the top and bottom flaps.

The second envelope in the picture has a slightly oriental feel to it. Again it is made from a rectangle of paper, and it best suits a rectangular card. Place your card on the rectangle at an angle of about 45°, as shown in the diagram above right. Ensure that there is sufficient paper

at each corner of the card for the folds. Using a bone folder, score lines which are the dimensions of your card plus 1 cm (0·4 in). Fold in the side flaps and then the bottom and top. No glue is required. The envelope can be secured with a tiny square of paper with an initial letter, or by string or embroidery silk which is pushed through holes poked through from the underside of envelope flaps C and D, and secured on that side with a knot and on the top side with a bow. To line the envelope, simply cut a piece of paper which is 0·5 cm (0·2 in) larger all round.

Wraps and folds

The simplest of wraps can still be very stylish. Some have additional flaps and folds for securing their contents. Small pieces or strips of unusual paper can be added for decoration to make what is a straightforward fold into something which appears to contain something precious.

Long wraps

The long wraps shown on page 56, would be suitable containers for bookmarks or long cards. The measurements here will contain the bookmarks from the previous chapter; for items of different dimensions, adjust accordingly.

Cut a rectangle which is 15·5 cm (6·1 in) wide and 22·5 cm (8·8 in) long. Mark lines on the underside of the

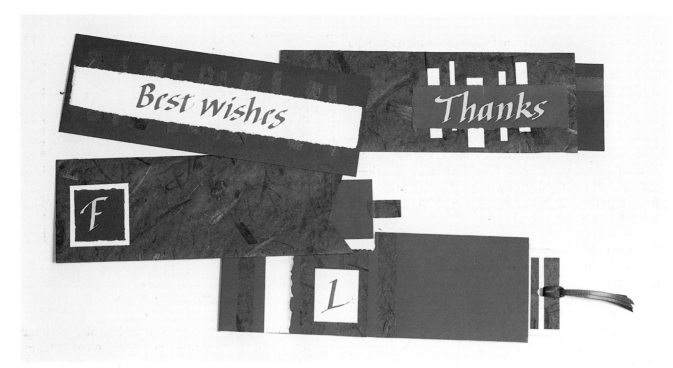

These simple envelope wraps can contain matching cards or bookmarks.

paper, which are 2·5 cm (1 in) and 10 cm (4 in) from edge A, as shown. Score along these lines with the point of a bone folder and straight edge. Now mark and then score a line which is 1·5 cm (0·5 in) from one end of the short edges, edge C. Carefully trim off the paper along where you have scored for the two shorter folds, and slightly taper the edges as on the diagram. Fold over the

narrowest flap A, run a line of glue along the edge of the wider flap B, and paste down. Glue a line along the bottom flap C and fold it up. If the paper is not too thick, you can fold in the top to make a slight v-shape as shown in the third (with the initial *F*) fold above, and use this as the front of your fold.

Decorate your wrap with contrasting and matching strips of paper, and add a message, initial or name to the wrap.

Wraps with pleats

These wraps have one side pleat, or pleats and so can take take larger and wider objects than just a bookmark or card. They are made in a similar way to long wraps.

For the tall wrap, cut a piece of paper which is 17 cm (7·5 in) wide and 26·5 cm (10·5 in) long. Mark and then score lines which are 3·5 cm (1·4 in) from edge *D* and 5·5 cm (2·2 in) from edge C. These are the main folds. To make the pleat, also score lines which are 7 cm (2·7 in) and 8·5 cm (3·3 in) from edge C. Fold in the top edges,

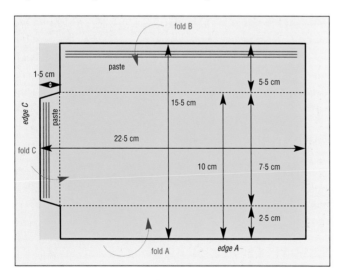

Simple wraps can be constructed to any dimensions and should be used for hand-delivered invitations, greetings cards and so on, as they are not secure.

as shown, to make an eventual v-shape. Mark and fold a line which is 1·5 cm (0·6 in) from edge *F*. Cut away all the paper apart from that for the front of the fold, tapering slightly as shown, (the pleats will make this fold too bulky if not trimmed away). Bend in the pleat at fold *E* and use the side of a bone folder to reinforce the crease. Bend over fold *C*, reinforce the crease. Run a line of glue along the underneath of edge *D*, fold, and use a bone folder to reinforce. Press the edge so that it adheres securely. Now run a line of glue along the underside of the bottom flap, which is folded up beneath the wrap so that it does not show on top.

The other wraps are made in the same way; the dimensions for the small wrap are – 19 cm (7·5 in) width and 13 cm (5·1 in) in length. The procedure is the same, but the fold from edge *D* is 2 cm (0·8 in) and that from edge *C*, 6 cm (2·4 in). There are two pleats this time which are 1 cm (0·4 in) each. The large bag is 27·5 cm (10·8 in) in width and 22 cm (8·7 in) in length. The fold from edge *D* is 4·5 cm (1·8 in) and that from edge *C* is 9·5 cm (3·7 in). Again there are two folds, each of 1·5 cm (0·6 in). To make the bag, use a hole punch to create

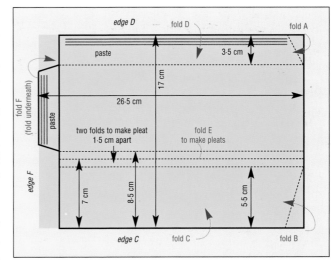

Wraps with pleats can hold lightweight but bulky gifts.

holes through from the front and back of the folds and measure out lengths of raffia which are 26 cm (10·2 in) long. Start on the outside of the bag and push the ends of some lengths through one hole and secure with a small piece of sticky tape or a small rectangle of the paper

Long wraps with pleats on one side can be used for gifts which are bulky. If giving more than one present, they look stylish when, as here, the theme is continued through all the wraps – each is in a different hand-made paper, but has the same style of label, and a rustic feel with raffia and brown narrow ribbon ties.

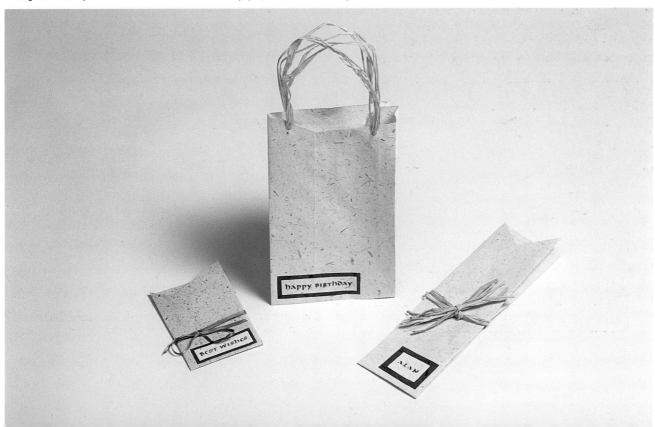

used for the fold. Repeat this for the other end, and for the lengths for the other handle. Write out your message and paste it on to contrast paper and then on to the wraps.

Folds with a flap

These folds are suitable for cards, invitations, menus, or special messages. They are secured with a flap, but have one open side. Choose a paper of at least 150 gsm in weight, as it has to withstand the flap being pushed into a slot, and lighter weight papers are not robust enough.

Cut a piece of paper which is 16 cm (6·3 in) in width and 21·5 cm (8·5 in) in length. Measure 8 cm (3·15 in) from edge *A* and remove a square which is 8 cm (3·15 in) as shown. Score lines at 8 cm (3·15 in) and 16 cm (6·3 in) from edge *B*, and 8 cm (3·15 in) from edge *A*. At edge *C*, measure 1·5 cm (0·6 in) from the scored line and mark this point along both sides. Now measure and mark a point which is 5·5 cm (2·1 in) from the same scored line and also mark the midpoint which is 4 cm (1·55 in). Trim this end into a point as shown using a sharp knife and metal straight edge. Also measure a line which is 3·5 cm (1·4 in) from edge *B* and mark the midpoint. Now, cut a

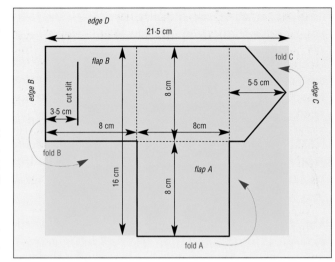

These folds with a flap are easy to construct and can be made to any dimensions.

slit which is 2·25 cm (0·85 in) long either side of that midpoint – 4·5 cm (1·7 in) long in all.

Fold in flap A, fold over flap B, and lastly the pointed flap, which then tucks into the slit. Write a name, initial letters or a message, and paste this on to contrasting strips of card or paper and then on to the fold itself.

Little folds with a flap pushed into a slot have an air of mystery about them, and create a feeling of expectation as the flap is pulled open to reveal the contents. One side is open, so they are easy to get into if you are making a batch of invitations, for example, or menus which will await each diner (see page 78).

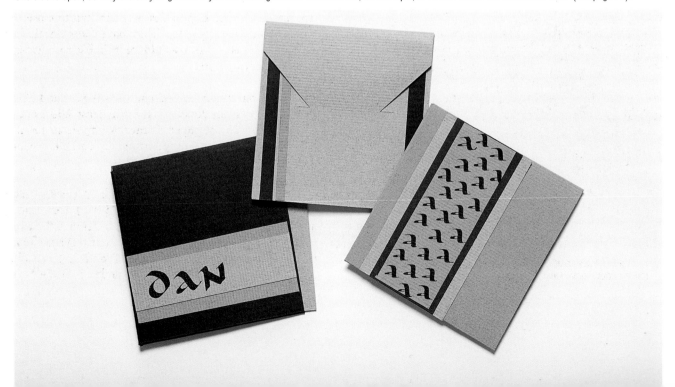

Folds secured with ribbons

These are very simple folds to make. Ensure that the width of the ribbon matches the size of the fold. If it is too wide, the fold is overwhelmed.

Cut a rectangle which is 24 cm (9·4 in) long and 14 cm (5·5 in) wide from a piece of paper which is about 150 gsm in weight. From either side of the long edge measure points which are 3 cm (1·2 in), and draw lines. Remove two rectangles from either side, leaving a rectangle which is 8 cm (3·1 in) wide and 12 cm (4·7 in) long. Taper the two edges of the remaining flaps as shown. Score lines at the base of these two flaps and also at a point 12 cm (4·7 in) from either end.

Before you make the final folds, cut an even number of slits (so that the ribbon can thread in *and* out again) which are just wide enough to take the ribbon. Choose where you want the ribbon to weave in and out, but ensure that your last slit on the top of the fold is not too near the edge, other-wise there will not be enough space to tie a

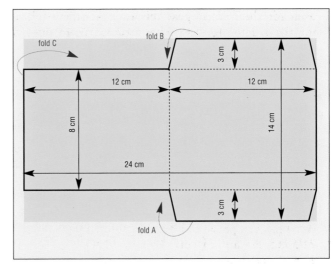

This fold is simple, with a few lines to cut and only one fold. It is easy to make and is secured with ribbon ties.

good bow. For this size of fold, you could cut slits at 5, 8·5, 14, 16·5, 18 and 21 cm (2, 3·4, 5·5, 6·5, 7 and 8·2 in). Cut a length of ribbon which is 55 cm (20 in) long, and push it through the slits. You may need to use the sharp point of a knife to encourage it to go through. Adjust the ribbon lengths and tie a neat bow. Trim the ends of the ribbon with scissors so that they are neat and even.

Folds with secure flaps

You can use either ribbon ties or a tab flap to close this type of fold (see opposite). They have flaps on all four sides so are secure and would be suitable to enclose a little hand-made book.

Cut a rectangle which is 17·5 cm (6·9 in) wide and 21 cm (8·1 in) long from paper which is at least 200 gsm, or card. The weight of paper or card is important because this fold has sides which support the top and bottom, and if this is too flimsy the fold collapses.

Cut the side flaps from this rectangle. Measure points which are 6·5 cm (2·5 in) and 15 cm (5·9 in) from edge C, and 3 cm (1·2 in) from edges A and B. Remove the paper from the edges as shown and slightly taper the remaining flaps. Now score lines at 6, 6·5, 15 and 15·5 cm (2·3, 2·5, 5·9 and 6·1 in) from edge C and 2·5, 3, 14·5 and

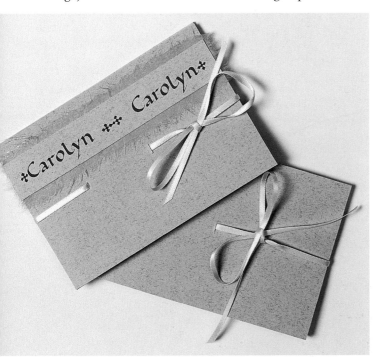

Ribbon-tied folds could contain special messages, or gifts such as paper money, tickets or vouchers.

15 cm (1, 1·2, 5·7 and 5·9 in) from edge B, as shown. Bend the folds over to make a wrap which has narrow sides.

The ribbon tie can be positioned at the top, middle or bottom of the fold. Cut slits which are just wider than the ribbon in the overlapping flaps from edges C and D, and also equidistant at the back. Cut a length of ribbon which is about 30 cm (12 in) long and thread it through the slits. Place your gift or book inside the fold, and then bend in the flaps and tie a bow in the ribbon.

To secure with a flap, slightly taper the folds from edges C and D, and cut a shape at edge D so that it makes a flap. Now cut two slits in fold C which are at 1·5 and 2 cm (0·6 and 0·8 in) from edge C. To secure, push the flap through the slits after folding.

The dimensions for the sides can be increased to allow for a book which is thicker than that allowed for here. In this case, remember to increase, too, the width dimension so that there is sufficient card to make the side flaps. Wider objects obviously require wider side flaps.

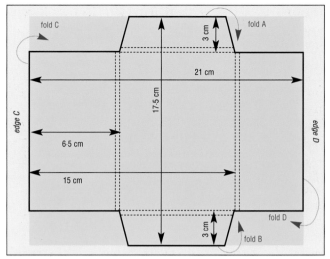

This fold has sides, which means that it can be used for a small book or gift which is bulky. Adjust the width of the sides so that it fits your gift.

Folds made into bags

These bags (see opposite) are a variation on folds, and can be made to any size and shape. The paper should be

This fold can be secured with narrow ribbon which weaves in and out of the top and bottom sides, or with a flap which fits into slots cut into the fold itself.

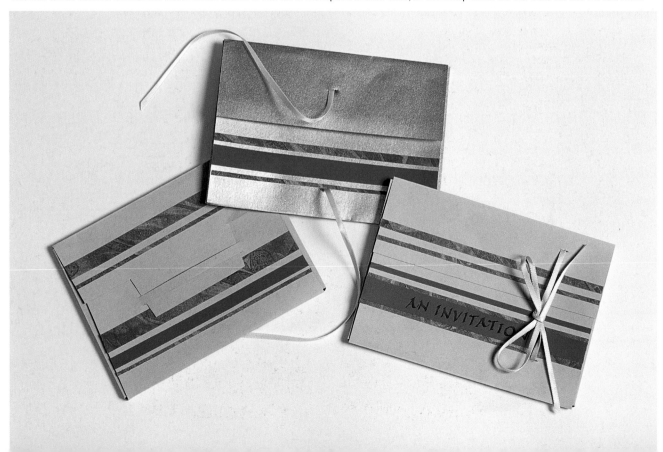

at least 150 gsm, or even thin card as the bags have to stand up on their own. Paper which is too lightweight will make for a rather floppy bag.

For the bag below which is purple with two torn pink horizontal stripes, cut a piece of paper which is 32 cm (13 in) wide and 25 cm (10 in) long. Mark and score two horizontal lines, one of which is 2 cm (0·7 in) from edge A, which is the top of the bag, and one 3 cm (1·2 in) from edge C which is the bag base. Now mark and score lines which are 1, 3, 5, 17, 19 and 21 cm (0·4, 1·2, 2, 6·7, 7·5 and 8·2 in) along the width of the paper from edge B. Cut narrow v-shapes for the base corners as shown. Now bend all the folds over and use the side of a bone folder to reinforce. Run a line of paper glue or PVA on the underside of the fold at edge A, fold it over, go over it with a bone folder and allow to dry. Paste along the narrowest fold at edge B and tuck the wider flap from the opposite end underneath. Allow to dry. Your bag is beginning to take shape. Fold under the two base side flaps, and the back flap of the bag. Now run a line of paste on the underside of the last, front flap. Bend this over the other flaps and put your hand inside the bag to the

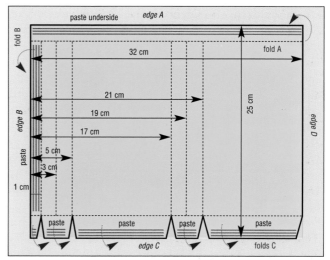

Bags for gifts are very easy to make.

bottom so that it makes a firm base for rubbing a bone folder over the pasted area to ensure adhesion.

To make the handles, cut two pieces of ribbon which are 32 cm (13 in) long. On the back of the bag measure points

Bags and folds in the same colour scheme are not difficult to make and are an attractive way to present a variety of differently sized gifts.

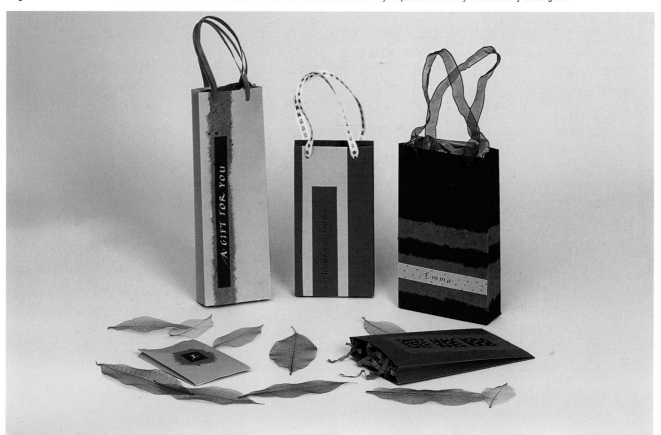

which are 1 cm (0·4 in) from the top fold and 2·5 cm (1 in) from the two side edges and use a hole punch to make holes. Repeat this for the front. Starting on the outside of the bag push one end of the piece of ribbon through the right-hand hole on the back so that there is sufficient to pull a length down and secure it with a piece of adhesive tape or a small pasted square of the same paper as the bag. Repeat this for all the other holes.

Decorate the bag with torn strips of paper of matching or contrasting colour and paste on a name, initials or message which you have written calligraphically in paint of a similar tone.

The other bags on page 61 were made in the same way. The tall pink bag is made from a piece of paper which is 23 cm (9 in) wide and 29·5 cm (11·5 in) long, with folds of 1·5 cm (0·6 in). The tall mauve bag has dimensions of 25 cm (10 in) width and 22·5 cm (9 in) length, again with folds of 1·5 cm (0·6 in).

To make the larger fold with side pleat, measure out a length of paper which has a width of 27 cm (10·5 in), and length of 21 cm (8·3 in). The pleats have folds of 1 cm (0·4 in) and the top fold 2 cm (0·8 in). Trim away all the folds at the base, apart from that at the front, which should have tapered edges and be tucked under and pasted at the back.

Triangular bags are an unusual and most attractive container for gifts.

Folds made into triangular bags

These triangular bags could not be simpler to make. Select paper or light-weight card of a weight similar to the previous bags, and cut a piece of paper with a width of 31 cm (12·4 in) and a length of 23·5 cm (9·3 in).

From edge *A* mark and score lines at 1, 11 and 21 cm (0·4, 4·4 and 8·4 in). Measure and mark the midpoint – 5 cm (2 in) – along side *B* and draw a perpendicular line as shown. Now draw a line from point *a* at an angle so that it is exactly 10 cm (4 in) long when it cuts this perpendicular line. Score along this line. Repeat this for the other side starting at point *b*. (If you have a protractor, measure angles of 60° to achieve this equilateral triangle.) Now draw lines for the flaps, which are 1 cm (0·4 in) wide, with slightly tapered ends, as shown opposite. Cut away the rest of the paper leaving this triangular shape. Score along side *B*. Bend and reinforce the folds with a bone folder. Run a line of paper glue or PVA along the 1-cm (0·4-in) first fold and tuck it under the third side to make a triangle. Now paste over the bottom flaps and tuck these up inside the back, pressing over the joins with a bone folder to aid adhesion.

Cut lengths of ribbon 28 cm (11 in) long and attach one end inside one side of the bag with a small piece of adhesive tape. Attach the other end to the second side. On

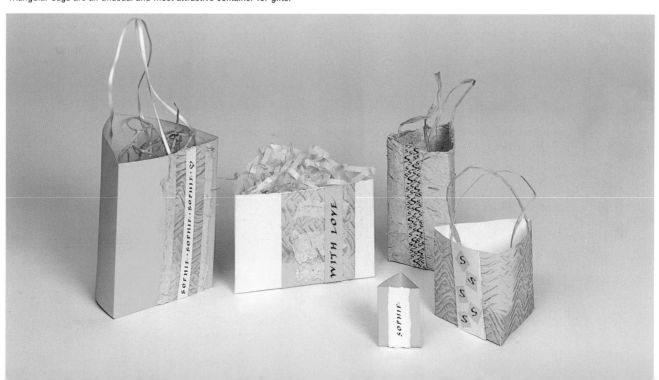

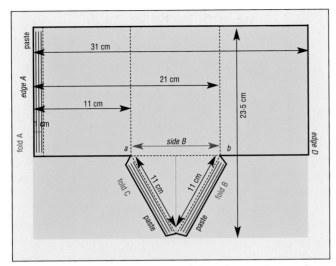

Triangular bags are very easy to construct, but require accurate measuring.

width and 16 cm (6·4 in) length for the small tall bag and 11·5 cm (4·5 in) width and 7 cm (2·8 in) length for the tiny container.

Decorate your bags with matching and toning lettering.

Boxes

Boxes can be simple or more complicated in construction, and can be decorated in a variety of ways.

Origami box with no glue

This box is constructed very simply and held together by folds. Use a paper which is about 150 gsm in weight (see page 8). If the paper is too lightweight then the top of the box is too flimsy, and if too heavyweight it is difficult to fold.

the same side attach one end of the second piece in the same way and then attach the other end to the third side. Or you could use a hole punch to make holes through which ribbons as handles could be inserted.

The other triangular bags shown here were made in the same way with a width of 25 cm (10 in) and length of 11·5 cm (4·5 in) for the patterned bag, 19 cm (7·5 in)

Cut a square with 15 cm (6 in) sides. Mark on the diagonals of the square with straight lines which join the corners. Fold one corner to the centre point, and then fold over again. Repeat this for every corner. The second fold makes the sides of the box. The square in the centre is the box bottom, so ensure that you maintain the

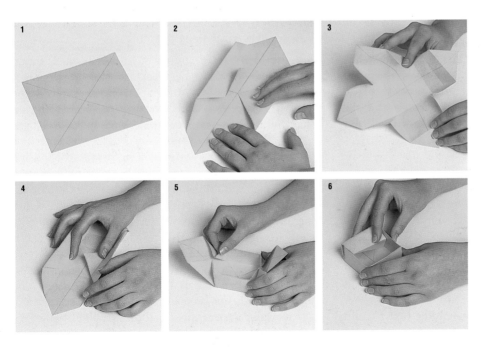

To make a square origami box:

1 With a pencil and straight edge mark the diagonals on a 15 cm square of paper.

2 Fold each corner into the midpoint and then fold over again.

3 On the top side, score and then bend in the diagonal squares as shown.

4 Place opposite points at the centre and bend up the sides.

5 Push in the scored diagonal squares to make the corners.

6 Pull over the top flap and tuck in. Repeat for the fourth side.

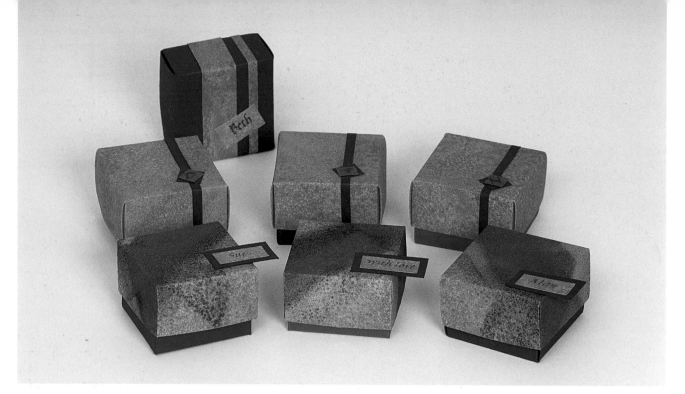

These square origami boxes have decorated lids made from a wet wash to which ordinary salt granules have been added and the whole allowed to dry. When dry the salt is rubbed off a mottled pattern is left. The blue and red boxes were made in the same way, but red and blue washes used before the salt added.

smoothness of this box bottom square. Then turn the paper over. Score the diagonal of the small square in the middle of each edge and then pinch the sides together from the underneath.

Position opposite points of the square at the centre and then fold up the sides. Hold the points in place and then with your forefingers push in the diamonds along the lines you have scored. This pulls the third side into place. To secure, pull over the top flap and bend it in so that the point is at the centre and the side is in place. Repeat this for the fourth side.

To make a lid repeat the process, but this time cut a square which has sides of 15·5 cm (6·2 in). The lids in the photograph above were made from paper which was decorated with a salt wash. Before you embark on this, make sure you stretch the paper (see page 112).

Because these boxes are so easy to make, and there is no actual measuring once you have cut your square, they can be made any size, down to 5 cm (2 in) and up to about 30 cm (12 in). Larger than this, though, the box bottom

and top are really too flimsy because the paper must be of a weight which can be folded. Too small and it is difficult to make and maintain the folds for the sides and corners.

Boxes with a sliding lid

These little boxes are similar to old-fashioned match boxes and have a sliding lid. They are made in two parts. The sides of the box base overlap, so it is best to choose paper which is of reasonable weight, say about 150 gsm, but not too thick, or this overlap becomes bulky and ugly.

To make four tiny boxes as shown in the photo opposite, cut four pieces of paper which are 5 cm (2 in) long and 6 cm (2·3 in) wide. Mark points which are 1 cm (0·4 in) from each of the four edges and draw a rectangle. Score along the lines just drawn. Extend these scored lines vertically (parallel to the short edges) as shown. Cut a slight v-shape from each of the four corners as in the diagram. Bend up all the folds so that the box is beginning to form. Apply paper glue or PVA to the *back* of one side flap and place this *in front* of the folded side, so that it is inside the box. Repeat this for the other flaps. Allow to

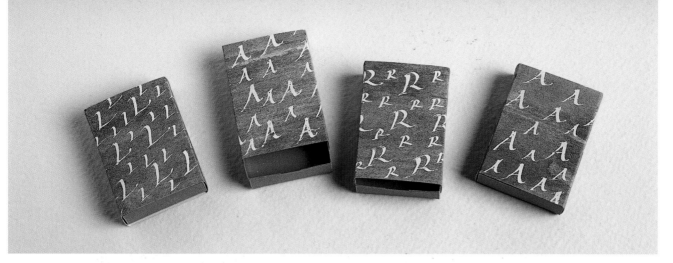

The sliding covers on these boxes are made from paper which is decorated with letters of the recipient's name written with resist (masking fluid), which has been allowed to dry and then covered with a wash of blue and green gouache. Once this is dry the resist is removed using a finger or eraser. It is probably best to reserve this idea for friends who have short names!

dry. The base of your box is now ready. Do the same for all the other box bases.

For the sliding top, cut four pieces of paper which are 4·1 cm (1·35 in) long and 10·4 cm (4·1 in) wide. Score lines which are 1·1, 4·2, 5·3, 8·4 and 9·5 cm (0·45, 1·75, 2·1, 3·3, and 3·75 in) from one of the shortest edges. Fold over the strip at these lines. You will find that the slide lid is already formed, and all you have to do is to run a line of paper glue or PVA along the final, short flap, and press this on to the other end of the strip to secure.

The paper for the cover of these boxes is decorated by a random pattern of letters, each box with a different initial. To do this, masking fluid was used. This is a rubbery solution available in art shops. Masking fluid is waterproof and acts as a resist, so when applied to paper with a pen or brush and allowed to dry, a wet wash laid over the top will not affect the paper protected by it. Masking fluid can be bought as a white or yellow liquid. The yellow colouring makes it easier to see where it has been applied. If only white is available, simply add a drop of dilute paint to give a pale colour. Experiment with

The base of boxes with sliding lids is made from one piece of paper with four small v-cuts removed.

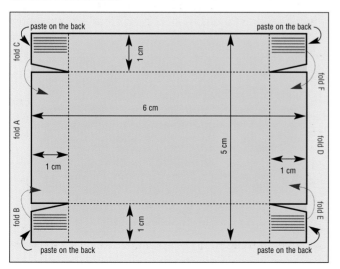

The lids are made from one piece of card which is wrapped round the base. Note that the proportions in these two diagrams are different.

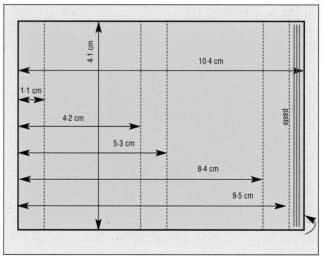

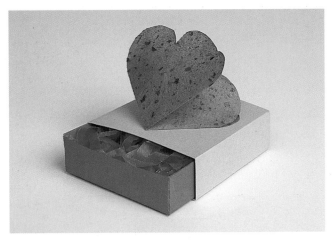

A square box with a pop-up Valentine's heart for your love.

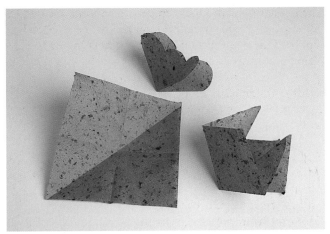

Making a pop-up heart requires one cut-out and a few folds.

masking fluid first. It can be a little sticky and so may be best to dilute it. However, too much dilution and it loses its ability to act as a resist. For the box lids the paper was first stretched (see page 112) and then a small nib and slightly dilute masking fluid were used to write initial letters over and over again at different sizes. When the masking fluid was dry, washes of green and blue gouache were painted over and allowed to dry. Then the masking fluid was removed using a clean finger or an eraser, revealing the letters in the colour of the original paper. If the contrast between the letters (which are the colour of the paper) and the wash is too great, simply apply a dilute wash once the masking fluid has been removed.

A slight variation on this shown above could be used for a small Valentine's day gift, for an anniversary or for a special present.

The box this time is square, but making the box and slide lid is the same. Cut a piece of red paper which is 8·5 cm square (3·2 in). Score lines 1·5 cm (0·6 in) from each edge to make an inner square, cut a v-shape at the corners, apply paste and stick. As before, the slide lid should be slightly larger so cut a strip of pink paper which is 18·5 cm (6·5 in) wide and 8·7 cm (2·1 in) long. Score lines at 1·6, 7·2, 8·8, 16, 17·6 cm (0·65, 2·7, 3·35, 5·4 and 6·05 in) and fold. Paste the back of the smallest flap to the other end to create the lid.

The pop-up heart is easier to make than it looks! Cut a square with 8·5-cm (3·3-in) sides from pink paper – the paper used here is hand-made tissue paper, which is strong – and fold it in half. Turn the paper and fold it in half again so that all these folds are on one side. Turn the paper over and fold across the diagonal. Go back to the first side and fold the paper into a square pushing the diagonal folds in as you do (see right-hand side of the photo above). Draw a heart shape to size (see page 50) and use this as a template for a heart on the folded paper. Cut only the two lobes, the point of the heart is made by the sides of the square. Paste the back of one of the hearts to the centre of the lid and the sides will make the front one pop-up.

You can decorate the sides of this box with calligraphy, and make sure that you add your name if the gift is precious!

Tall boxes with a detachable lid

Tall boxes like the ones shown opposite could be used for keeping small calligraphic tools and equipment in, and without a lid would serve as useful pencil and pen pots.

For these boxes you will need stout card, the sort that forms the back of a pad of art paper will be ideal. The box has to be stout as it is the card which gives it strength.

When I first started to make these boxes, I tried cutting out all four sides and base from card and then pasting

them together with PVA. I spent a lot of time holding the sides together and trying to stop the whole thing falling apart. With experimentation, I found that in fact the best thing to do was to cut out the shape of the box from one piece of card and then simply score the outside of the folds with the blade of a pair of scissors and bend up the sides. Only these corners then need pasting and the box is that much stronger.

Cut out a piece of card which is 27 cm (10·5 in) square. Measure 10 cm (4 in) from each side and draw another square. Cut out the corners. The sides of these boxes sit within the front and back sides, so now measure 1 mm (0·05 in) from both edges of the two side flaps and cut this away too. Turn over the card and with the blade of a pair of scissors and a metal straight edge, score along the sides of the inner square. The aim is to break the surface fibres a little, not cut right through. This will make it easier to fold up the four sides.

Bend up the sides and run a line of PVA along each one. Press them together. It may be easier to hold the corners in place with strips of masking tape which can be peeled off when the paste is dry.

Now cut the lid from the same weight card. Inside the lid is a 'filler' which helps it sit securely on the box. The dimensions for the lid are a square which has sides of 7·5 cm (3·1 in), and for the filler a square which is 6·5 cm (2·7 in). Cut these from the card using a sharp knife and straight edge.

The paper for covering is 80 gsm photocopying paper; this is the normal weight paper for photocopying. Here it has been decorated using a natural sponge dipped in colours of calligraphy gouache and then dabbed all over the paper to make an even pattern. For the two-colour version, wait for the first colour to dry. The paper for the inside of the lids is slightly different in that only one colour has been used.

Once the box has been assembled and stuck together the sides of the box on the outside are covered first. Cut a piece of paper which is 12 cm (4·7 in) wide and 29 cm (11·5 in) long. Each side of the box is 7 cm (2·7 in) tall.

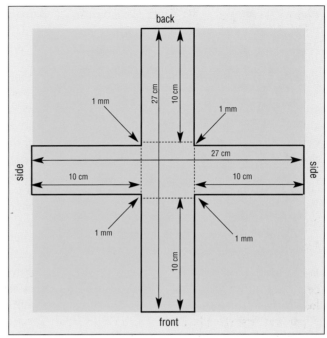

Tall covered boxes are cut from one piece of card.

These covered boxes with detachable lids are covered with paper decorated with coloured gouache applied with a dry sponge.

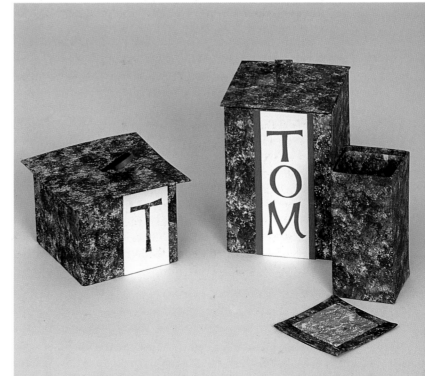

Along the length of the paper strip measure and mark points which are 6·5, 13·5, 20·5, and 27·5 cm (2·5, 5·3, 8, and 10·7 in), and draw vertical parallel lines. Now measure 1 cm (0·4 in) from the top and bottom edges of this paper strip and draw horizontal lines. Where these lines cross indicates where the corners will be, so at each cross point cut a very narrow v-shape, but take care not to cut into the long horizontal lines otherwise the paper will not cover the box at the corners. Paste over the back of the paper with PVA. Carefully place the box with the top edge at one of the long pencil marks and the bottom left-hand corner lining up with the marked line at 13·5 cm (5·3 in). Press down, and then pick up the box with the paper attached, place a piece of clean paper on the covering paper and then rub over with a bone folder to help adhesion. Now rub down the short length of covering paper. Roll the paper round the next side and rub down and then repeat for the last side. With the box still in your hand, tuck under the bottom flaps and rub them down with a bone folder, and now do this for the top flaps. The covering paper should have covered the corners cleanly.

Cover the inside of the box by cutting a strip which is 10·5 cm (4·1 in) wide and 29 cm (11·5 in) long. Measure the inside sides of your box and transfer these measurements to the paper strip, drawing vertical parallel lines on the underside of the paper. Measure and draw a line 1 cm (0·4 in) up from the base and draw a line. Cut narrow v-shapes where the lines cross, and taper the two ends slightly. Score along these lines and fold up. Position this paper inside the box. The vertical folds should fit the corners, and the long 1-cm fold tucks on to the floor of the box base. At this point it is possible to adjust the folds if your measurements have not been overly accurate or the box card is very thick. Remove this paper, paste over the underside and bend it round to shape, tucking up the bottom fold so that the paste does not transfer too much to other parts of the box. Place it inside the box, ensuring that the top is straight and the strip is about 0·5 cm (0·2 in) from the top edge. Once you are sure that it is straight and in position use a bone folder to position and push down the front of the paper. Slide the paper so that is fits into the corners, and, starting with one side, rub over with a bone folder over paper so that each side is covered well, and then do the same for the base.

Cut two pieces of paper for the inside and outside bases, which should be squares with sides of 6·4 cm (2·5 in). Paste over the underside of one and position it on the outside of the box base. Rub over with a bone folder over paper. Repeat this for the inside box base.

Now cover the lid. If you wish to make a handle, this should be done first by either cutting a strip of matching paper which is then pasted and folded in half, or by using matching ribbons. Cut a square of covering paper with sides of 9·5 cm (3·7 in). Measure and mark a line 1 cm (0·2 in) in from each edge and draw pencil lines on the underside. Cut bookbinder's corners (see page 98). Before pasting the covering paper to the lid, if you are making a handle, mark the centre point of the covering paper, and make a slit which is sufficient for the handle you are to use. Push the handle through from the top side and paste down on the underside. Now paste over the underside of this paper. Position the card lid on the pencil drawn square, turn over and rub over with a bone folder over paper. Tuck over opposite edges to make neat bookbinder's corners. Repeat this for the filler, but this time the square of covering paper should have sides of 8·5 cm (3·3 in). Paste over the uncovered side of the filler when it is dry and press it to the lid ensuring that the edge is even all round. If possible, dry under a weight by placing pieces of baking parchment, or silicone paper on top and underneath the lid and putting these on a clean flat surface. Place a heavy book or weight on top. Allow to dry; this may take some hours.

The decoration for these boxes was done by designing letters, and then cutting them out from contrasting coloured card with a sharp knife. The paper was then pasted on to the box side. The cut-out letters themselves could be used as decoration elsewhere.

Pencil boxes with hinged lids

These are boxes constructed from card which is then covered with paper and decorated with calligraphy. Here they have been used for pencils, but could equally well serve as jewellery or treasure boxes.

These boxes need a stout card for their construction and that of a similar weight to the previous boxes is best.

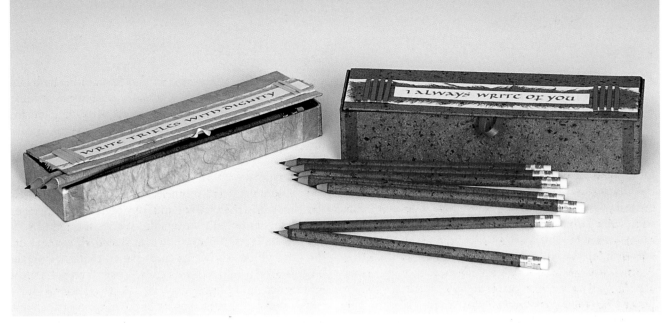

Covered boxes with hinged lids can be used for pencils, jewellery or other treasures.

Cut out a rectangle of card which is 10·5 cm (4 in) wide and 25 cm (10 in) long. Measure points which are 2·5 cm (1 in) from each edge and draw an inner rectangle on the card using a pencil and straight edge. The sides for the box will sit within those for the front and back, so you will need to trim away an additional 1 mm (0·05 in) each side. To be completely accurate, measure the width of the card and remove a fraction more (to allow for the covering paper) than that amount from each end of the side flaps. Remove these corners. Decide which is to

be the front of your box base and mark it with an *F*. Now trim 1 mm (0·05 in), or the width of the card plus a fraction, from the top front of the box, so the when it is made the lid sits flat with the other three sides, resting on the front side. Turn the card over and use the blade of a pair of scissors to score along the sides of the inner rectangle. Bend up the sides and use PVA to stick them together, with no overlaps, to make the box base. It may be easier if you use strips of masking tape to secure the joins until the paste is dry.

The cardboard base for a pencil box.

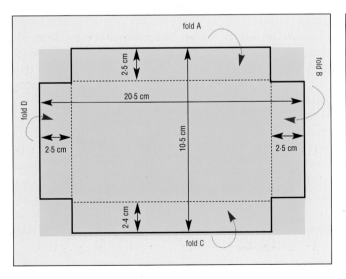

The template for covering paper for the right-hand side of the pencil box.

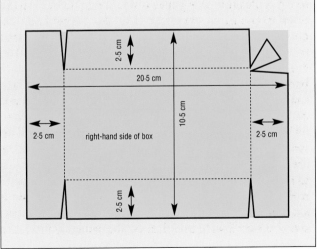

The lid is made from one piece of the same weight of card which sits just inside the box base. Cut a rectangle which is 6 cm (2·3 in) wide and 19·8 cm (7·8 in) long.

You will also need material for the hinge. This could be fabric which is a matching colour and will show just at the hinge (you will then have to cut the covering paper at this point to reveal the coloured fabric) or it could be a neutral colour, as this design covers the hinge with paper. Another possible material is that which is used to make very strong, but thin, envelopes, the sort which have to be cut open with scissors (Tyvek®). Cut a length which is 3 cm (1·2 in) wide by 19·5 cm (7·6 in) long.

Once the boxes have been constructed they are now covered in the chosen paper. A paper which is thin but strong is best for this, as it has to be pasted over corners and also overlaps itself at some points. The paper used for the boxes on page 69 is hand-made Japanese tissue paper. This is very strong even when damp with paste, and moulds easily around the shapes of the box. It also has no grain direction (see page 14) so this does not have to be taken into consideration when covering the cardboard. If the paper does have a grain direction then that for the paper should be the same as that for the cardboard.

Cover the box first. Cut two pieces of paper to cover the sides and which are 7·5 cm (3 in) wide 4·5 cm (1·8 in) long. Place the right-hand side of the box on one piece of covering paper which is lying face down, and ensure that there is 1 cm (0·2 in) of paper at the bottom, top and both sides. With a faint pencil line on the underside of the paper draw accurately around the side of the box. Mark the top of the box on this paper with a faint letter *T*. Now cut a small wedge shape into the paper at the right top corner, as shown on the diagram on page 69. The narrowest part of this wedge should be the width of the card used for the box. Cut very narrow v-shapes out at the top left-hand corner and at the two base sides of the covering paper (see page 69). Do not cut into the area which you have drawn with a pencil, or the paper will not cover the box. Paste all over the underside of the paper using PVA or liquid glue (not paper stick glue because you need to slide the paper a little over

the box base). Place the box side carefully on the pencil outline and fold over the wedge piece using a pointed bone folder to push the paper into the slight dip and corner and then flat on the inside of the box. Place a piece of clean scrap paper on the covering paper and use a bone folder to rub over the side of the box ensuring that the paper is flat and a good fit. Now bend over the top fold and tuck it down into the box side. Bend over one of the side folds, rub over with a bone folder and paper and then the do the other side. Lastly, tuck under the bottom fold and ensure that it is pasted securely under the box. On the other piece of paper, mark the wedge piece on the left-hand side of the box and repeat for the other side.

Cut one piece of covering paper for the front side. This should be 4·5 cm (1·7 in) wide and 19·7 cm (7·8 in) long. Paste over the underside of the paper, and position the front side of the box base on the paper so that it is central with an overlap of 1 cm (0·2 in) at the top and bottom. Rub over the front with a bone folder over a piece of paper. Tuck under the bottom and top folds.

Now cover the inside the box. Cut a piece of paper which is 2·5 cm (1 in) wide and 33 cm (13·2 in) long. On the underside, draw a line which is 1 cm (0·4 in) up from the long edge; score along this line. Now measure and mark points with a pencil along this line at 1 cm, 5·5 cm, 20 cm, and 25·5 cm (0·2, 2·2, 7·8, and 10 ins), and score vertical lines at each point. Cut slight v-shapes at these points, from the edge of the paper to the drawn pencil line at 1 cm (0·2 in) up. Position this paper inside the box. The two folds of 1 cm (0·2 in) go at the back of the box, the rest of the vertical folds should fit the corners, and then the long 1 cm (0·2 in) fold tucks on to the floor of the box base. At this point it is possible to adjust the folds if your measurements have not been overly accurate or your card is very thick. Paste on the underside of the paper, bend the paper round to shape, and tuck up the bottom fold so that the paste does not transfer too much to other parts of the box. Once you are sure that it is straight and in place use your bone folder to position and push down the front of the paper. Do the same for the two sides and lastly the 1 cm (0·2 in) overlaps at the back and on the base.

Then attach the lid. Measure and mark the midpoint on the fabric hinge and draw a faint horizontal line across its length. Score along this line and fold in half. Paste this hinge, and position the lid on it so that the lower edge of the lid is parallel to the drawn pencil line. Rub over with a bone folder. While the paste is still wet position the hinge inside the box along the back side. Lift the lid up and down to ensure that the hinge is not positioned too low (which would prevent the lid closing), nor too high which would push the lid too far forward on the box. Rub over the pasted hinge with a bone folder.

Cover the lid and the inside back of the box next. Start with the outside of the lid. Cut a piece of covering paper which is 21·7 cm (8·5 in) wide and 10·7 cm (4·2 in) long and place it face down. Position the back of the box with the lid open on the underside of the covering paper, with 1 cm (0·2 in) of overlap at the base and draw faint horizontal lines on the paper marking the top and bottom edges of the box.

Now place the lid carefully flat on the paper, lined up with the 1 cm (0·2 in) line you have just drawn, and draw pencil lines to mark the sides. Make a bookbinder's corner (see page 98) at the front sides of the lid, and cut corners to shape. Now make a small horizontal cut 1 cm (0·2 in) long at the base of the lid. Cut out a narrow v-shape from the bottom of this piece of paper at the 1-cm (0·2-in) line you have drawn. Paste over the back of the covering paper. Position the back of the box so that the base lines up with the first 1-cm (0·2-in) pencil line drawn. Rub over the back with a bone folder over paper. Use the point of the bone folder to tuck the paper over the fabric hinge so that it is snug but not stretched.

Next tip the box so that the lid is flat on the surface and the covering paper sticks to it. Rub over as before. Bend over and tuck in first one side and then the other on the lid, and finally bend over the top fold of the paper. Rub over to ensure a good adhesion. Work your way back down the box lid. Tuck round the side flaps in turn and tuck the little corners under the base. Last of all push the flap under the base of the box.

The inside box lid is easier to deal with as it is just one straight piece of paper. If you wish to attach a little ribbon handle then it should be cut and pasted at this point. Cut a piece of narrow ribbon which is 7 cm (2·5 in) long. Mark the midpoint of the box, and then two points which are 0·5 cm (0·2 in) from this. Paste each end of the ribbon (making sure that it is not twisted when it is attached) and press the two ends down on the underside of the lid. Allow to dry. Cut a piece of covering paper which is 19·4 cm (7·6 in) wide and 9·5 cm (3·7 in) long. Paste over the underside of this paper. Position it carefully on the underside of the lid so that there is an even margin all round. Rub over with a bone folder over paper, and then work your way down the inside of the box and on to the box floor.

The last stage is to cut two pieces of covering paper which are 19·5 cm (7·7 in) wide and 5 cm (1·9 in) long so that the inside and outside bases of the box are covered. Paste over the underside of one and position on the box base so that there is an even margin all round. Rub over with a bone folder over paper. Repeat this for the inside of the box. Allow to dry.

Lastly decorate your box calligraphically. For the pencil boxes shown on page 69 a suitable phrase connected with writing was written on white paper using calligraphy gouache matching the colour of the paper. This was pasted on to a strip of the covering paper and then on to a wider strip of white paper. Lastly, short lengths of narrow ribbon were cut and pasted on the white paper for decoration, and then the whole pasted on to the lid of the box. (The pink box was made in the same way as the blue, but the sides are twice as high.)

5 celebrations

Celebrations and calligraphy go together particularly well. To make an occasion special a degree of effort is required, and lettering invitations and envelopes, place names and menus so that a theme is carried through the event will take time, but be worthwhile. For children, the theme can even extend to party bags, which little guests take home with them full of goodies. The advantage of technology means that the repetition of having to write out invitations and menus many times over has now gone, and most people have access to computers or photocopiers which can reproduce multiple copies from paste-ups. Of course, you can always still hand-letter and decorate a limited number of invitations and not use technology if you wish, though this will take much longer, and you will have to repeat an invitation if you make a bad mistake.

Children's parties

It is a good idea to introduce a theme for a child's party, as everything can then be linked to it. Depending on your artistic skill, you can trace round a drawing of a cartoon or literary character or invent your own. The theme of balloons would be appropriate for most young children and they are not too difficult to draw. It is easy to personalize them too, even when you have made copies

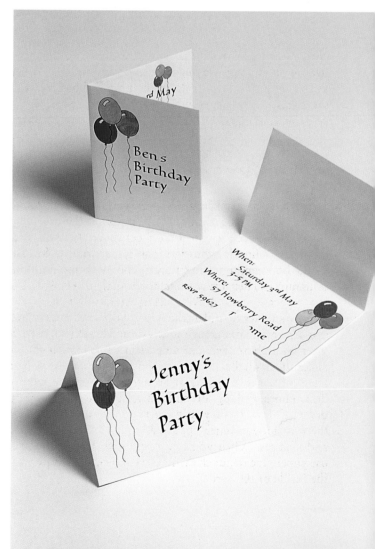

Invitations for children's parties can be very simple but attractive. These are variations on a basic idea which have been printed on a photocopier. The balloons were left uncoloured, but then painted in red, green and yellow after copying.

of the invitation on a photocopier, by painting the balloons different colours, or getting the birthday boy or girl to colour them with paints or felt tip pens.

Decide on the wording for your invitation. Choose a script which is suitable for your theme, and select a size of nib with which you are comfortable. The joy of using a photocopier or scanner and computer is that you can write larger than is required, and simply reduce the lettering, using the technology available.

Draw lines on a piece of white paper which are the correct size for the x-height of your chosen script and size of nib. Using a dense black ink write out the words, not worrying if you make a mistake as the correct letter or word can always be inserted. If you are not happy with any word or phrase when you get to the end, simply rewrite it.

Now design your balloons. They are simple to draw, an oval with a long waving line representing the string attached to a squiggle at the base of the tied balloon. On the ovals draw shapes which suggest the reflection of light. When you are satisfied, draw round the balloons with a fine-pointed black pen, stick one over another, or arrange them how you think best. Cut out the balloons, leaving a narrow surround of white paper.

On another piece of clean white paper, place the balloons on the top-left corner, so they look as though they are floating into the air, and paste them down. Now draw a faint pencil line for the right and left margins allowing space between the strings from the balloons and the calligraphy. Then draw faint horizontal pencil lines for the separate lines. If you prefer certain words to be slightly smaller than the rest (e.g. *When?* and *Where?* are smaller on one of the invitations shown here) then reduce them on a photocopier, or scan them into a computer and make them smaller in this way. Cut out the best words from your calligraphy and arrange them on the newly-drawn lines, making sure that, first, they are in the correct order (this is an easy mistake to make) and, secondly, there is not too much space between the cut-out words and phrases. When you are happy with how they look, use paper glue to attach them to the paper. Repeat this for the inside of the card.

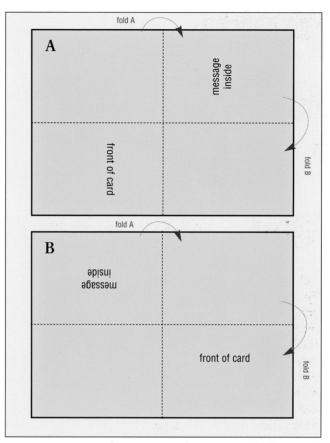

When folding paper to make a card, decide whether you want the final fold on the left-hand side or along the top. For a left-hand fold, arrange the wording as shown on A; for a card with the final fold along the top, arrange the wording as on B.

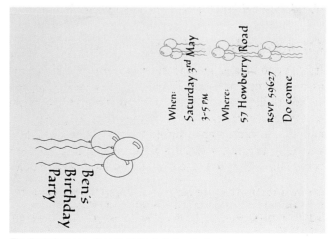

The final photocopy for one of the invitation designs.

If you are using a scanner and computer/printer, then scan in your design and arrange it on an A4 template so that you can print it on to paper or light-weight card. Use the diagrams on page 73 to help you position the lettering if you are using paper, which is then folded into four. If you have a colour printer you could change the colour of the lettering from black, although take into account the colour of the balloons which you will paint or colour in with felt tip pens.

When using a photocopier, it is often best to reduce your design to the size you want first and then paste this on to a piece of A4 paper in the correct positions for paper or card. Make one good copy so that everything looks correctly aligned before you make multiple copies. (It is sometimes a good idea to use this good copy for the rest as any pick-up from the calligraphy can be eliminated first.)

Each card can have different coloured balloons. Often it is a good idea to add a hand-crafted touch to something which has been printed.

Why not continue the theme at the party with party bags? Use the design for bags on page 61. From an A4 piece of 150 gsm paper you can make one bag which has the dimensions of front and back panels with a width of 12 cm (4·7 in) and height of 13 cm (5·1 in) and sides of 2 cm (0·7 in). These will easily accommodate a few trinkets and sweets or candies.

A house warming

Although balloons are usually associated with children, they can be linked to any celebration. A house warming invitation can be made as fun or as sophisticated as you wish, depending on your colour scheme and approach.

Matching invitations and envelopes make an occasion as simple as a house-warming into something very special, and will ensure a good response from your guests.

Party bags continue the theme.

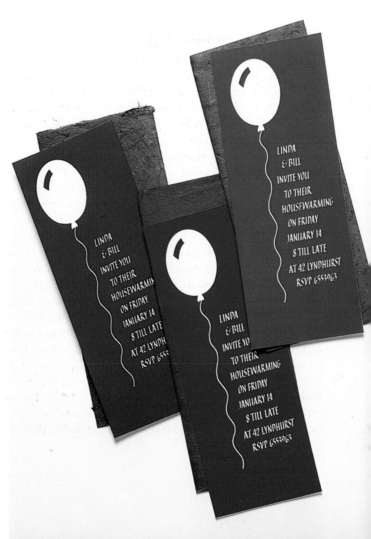

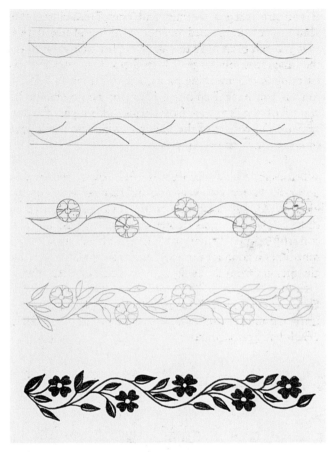

Choose your wording, script and nib size and write out the words in dense black ink on white paper as before. Cut out the best words and arrange the lettering to follow your chosen design. Use a scanner to manipulate the size on a computer, or use a photocopier. On your computer you can probably change the colour of the background and lettering and many commercial photocopiers can do this, too. Long narrow invitations like these are very economical as you can print three on a sheet of A4 which will cut down the overall costs of printing and photocopying, or mean that you can ask many more people to your celebration! Make envelopes to match and the end result is very stylish indeed.

For these invitations, the image of the balloon was painted completely in black (apart from the 'light' reflection). On a computer this was converted into white (it could have been in any colour) so that it matched the lettering.

A formal wedding

Wedding invitations are usually typeset in a formal way by printers using limited styles of script. The wording for an invitation like this can be all in one style and in one size which is how it is often set by printers. However, you have differently sized nibs at your disposal. You can write in the names of the happy couple in a larger size and details in a smaller size, as shown on page 76. You could also introduce a line drawing of flowers to add interest, and take the whole paste-up to the printers for multiple copies. They will be able to reproduce your artwork the same size or at a reduced size.

Make sure that you mark on the paste-up the planned margins of your invitation. Use a pale blue pencil for this as this is the traditional colour used to indicate margins for printers. It is a colour that is not usually picked up when being processed, which means that these lines should not show when printed. In any case, do not draw completely round the edge of your paste-up with a blue pencil. Indicate the actual margins (the crop marks) by pairs of horizontal and vertical lines at least 1 cm (0·4 in) away from the corners themselves, see page 76. If you know how to work out the percentage by which your artwork should be reduced, then include this in

Designing a decorated border. This can be placed vertically on the left of the invitation text as shown overleaf, or could be positioned horizontally towards the bottom of the invitation below the text.

your instructions to the printers. If not, then simply indicate that the artwork should be reduced to fit a particular size. Remember when doing so that it is a good idea to ensure that these dimensions correspond with a standard envelope size, unless you intend to make the envelopes yourself. As a safeguard, it is wise to make a photocopy of your artwork reduced to the required finished size and include this with the information you give to the printers.

The floral design to go with the invitation shown on page 76 is not difficult to do, as it is simply a black outline. If you find a simple border which you think will be sympathetic to your lettering, then you can use this for

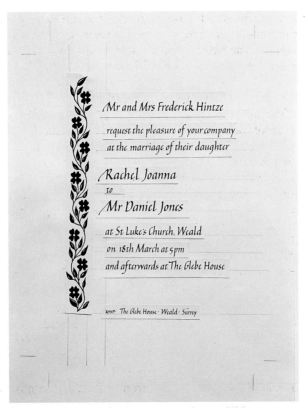

The paste-up for a formal wedding invitation.

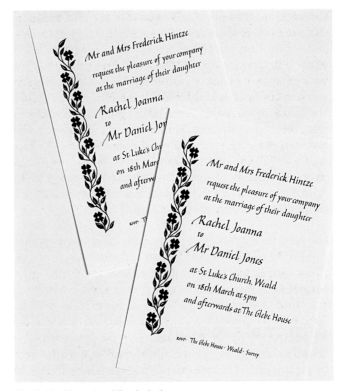

The finished formal wedding invitation.

inspiration. Flowers and leaves seem best for weddings, rather than a heavy symmetrical or overly complicated design. Your artistic skills may be limited, but almost anyone can trace, and because your artwork must be in black, even though the final printing may be in a colour, all you need is some white paper and a fine-pointed pen. The key to any design like this is to ensure that your plant or flowers look as if they could be growing. Stems should be curvy and not have right-angled joins. Similarly the leaves must look as if they grow out of the stalks.

Decide how tall your design needs to be, you can always reduce it in size if necessary. Using a pencil and straight edge draw a vertical line to size, draw two more vertical lines which are 0·5 cm (0·2 in) either side and measure and mark along the centre line regular lengths, say every 2 cm (1 in) – this depends on how large the final design is to be. Work in pencil first and faintly draw a line which curves evenly between the marked lengths, and between

either side of the middle line. This is your main stem. You can make your design informal if you wish; this design is rather formal. Draw on the main side stems at regular intervals, either side of the main stem. If you are to include flowers, then design these now. The easiest ones are based on a circle. For the prototype, you could use a set of compasses or draw round a small coin to make a circle. Divide the circle into four using a pencil and straight edge and mark the centre as a small circle. Use the divisions into quarters to help you draw four even petals which dip slightly at the outer edge. (If you have one which you particularly like and draw well, then do consider photocopying this after you have painted it in black, and then place copies of it in position on your design.)

You may choose to make a flower with more petals, or a different flower design, but do remember that calligraphy and artwork are in competition. In this case you want people to read the information and not to have their eye

drawn to the artwork all the time by the use of too many different flower designs.

Place the previously photocopied flowers at regular intervals along the stem, or draw flowers which match the one you have just drawn along the stem. Now fill in the spaces with leaves and smaller stems to make a light but even design. When you are satisfied with your design, you can either trace it, using light-weight paper such as layout paper and a fine black pen, or go over your design in ink and cut it out to paste with your calligraphy. As it is to be printed, you can remove any mistakes or dark pencil lines with white correcting fluid or white gouache.

An informal wedding

Weddings, as with many other occasions, are getting less formal, so perhaps a slightly different approach will suit the bride and groom. For the invitation below Uncial letters have been used. Because Uncials have so few ascenders and descenders, the lines could be arranged so that they are close together, and ranged around a central point (though not centred). To keep to a degree of informality, the invitations were printed in mauve on a

white card which could match the dresses of the bridesmaids or perhaps the flowers in the bride's bouquet. The lettering on the invitations could, though, be any colour on any coloured card.

To avoid potential problems of reply, it is often helpful to enclose a reply card, especially if, as here, there is a choice of menu, or allowance has to be made for food preferences and allergies. This, with the invitation, has been enclosed in a hand-made folder, which uses strips of the lettering used for the card with a torn strip of hand-made paper which matches the lettering on the invitation. Any additional information, such as a map, can be enclosed also in the folder.

To make a folder which will hold an invitation and reply card each with the dimensions of 12 cm (4·8 in) wide by 10 cm (4 in) high, choose a matching or contrasting paper (at least 150 gsm) or preferably light-weight card. Cut a piece that is 29 cm (11·5 in) wide and 15·5 cm (6·1 in) long. Mark and score a line which is 14·5 cm (5·7 in) in from edges *A* and *C*. Now mark and score a line which is 4 cm (1·5 in) from edge *B*. Draw a vertical line which is 1·5 cm (0·6 in) from edge *A* and remove all

The invitation and reply card for an informal wedding. As a trial the lettering was made white and the invitation mauve, but this was thought to be too heavy for the occasion.

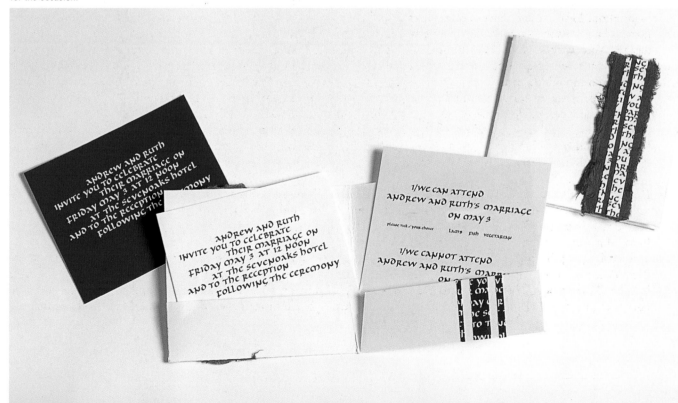

but the base tab, as shown. Repeat this for edge C. Cut a v-shape from the horizontal scored line to edge *B*. Bend over the folds and reinforce with the side of a bone folder. Run a line of paper glue or PVA down the edge of one of the tabs, and attach it to the main part of the folder as you bend up the bottom fold. Repeat this for the other side. Decorate the outside of your folder using strips of lettering from the invitations.

The same theme can be continued through to the table arrangements and place setting. The menu shown below is lettered using the same script and style of layout, and enclosed in a folder (see page 57), so that there is almost an element of mystery about what is to be served. The place names are written on folded cards and the little boxes (see page 65) containing sugared almonds are made from matching card, strips of hand-made paper and lines of lettering from the invitations.

If you wanted to take the idea even further, you could make your own confetti. This does take time and is a little fiddly, but is very effective, and some can be used, as here, to decorate the table. Using very faint pencil lines and a straight edge divide a piece of white A4 paper into

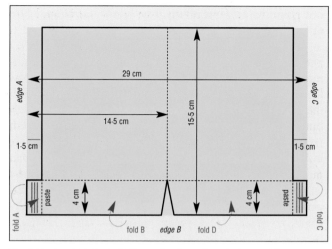

The folder in which the invitation and reply card can be inserted for an informal wedding.

small squares which have sides of 1 cm (0·4 in). Leave the first left and last right spaces and top and bottom lines blank, as photocopiers and printers do not usually pick up the very edge, and it is a waste of your lettering if it is

Menus, menu folders, place names, confetti for the wedding and a little souvenir box containing sugared almonds are all presented in the same colour theme and style for an informal wedding.

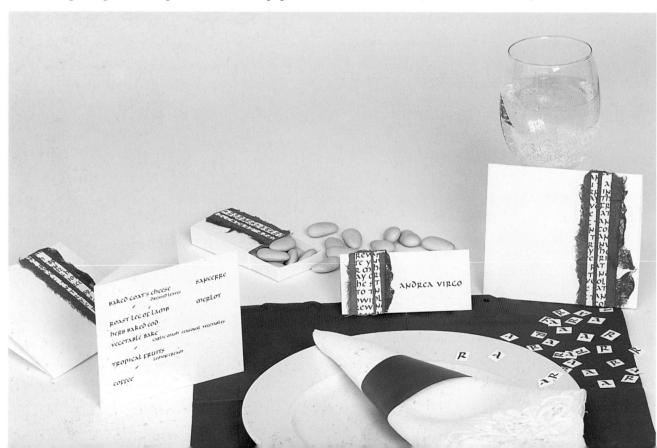

not going to be reproduced. Now draw horizontal lines as guides (if you wish). Choose a nib size which will fit into the square you have drawn without being too overpowering. Using dense black ink, write the initials of the couple in the squares alternately on successive lines. Either photocopy your lettering on to ten sheets of paper, or scan it into a computer and print off the same number of sheets, changing the colour if you wish. If you have used a computer to print the invitations, then you can use letters from that invitation, having marked out a template for their position using a suitable computer program. Then print off the sheets. Either using a sharp knife and metal straight edge, or a rotary trimmer, cut the sheets into small squares to make the confetti.

A silver wedding

The colour scheme for this anniversary is usually, obviously, silver, and the occasion is often elegant, so the invitation,

menu and table setting should reflect this. Silver, black and white were chosen for the colour scheme.

Decide on the wording for the invitation and letter it using dense black ink on white paper and the sizes of nib you feel appropriate for all the information, and cut out the best words you have written. Draw horizontal lines the distance apart of your chosen design on a clean sheet of paper. Arrange these along the lines according to your design. Allow for the wide decorated border and the narrow strips of coloured paper. Photocopy or scan and print the invitations.

The 'twenty five' design strip was made by mixing a pinch of domestic wallpaper paste into a palette of black ink or gouache, and allowing a few minutes for the paste to swell. While this is happening, draw horizontal lines 4 cm (1·7 in) apart on a sheet of white paper which is about 250 gsm in weight (this will save you having to stretch the paper). Also cut a pen from a small length of balsa wood

The menu, place name and souvenir 'keepsakes' folder for a silver wedding anniversary party.

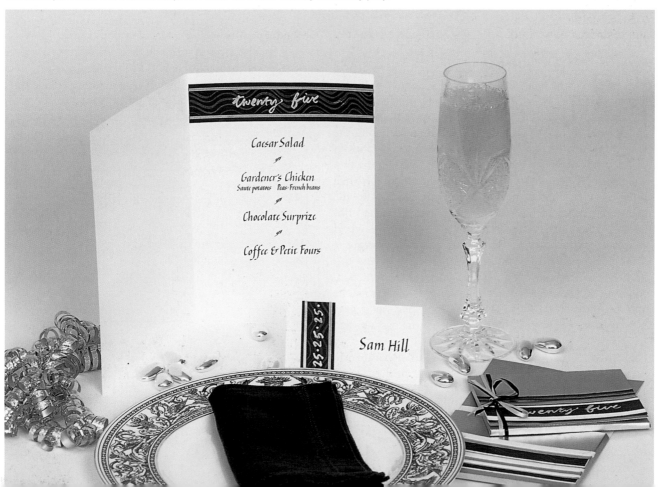

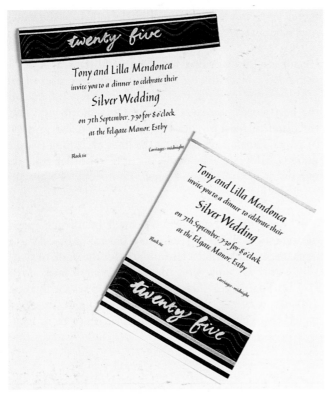

Invitations for a silver wedding.

Making a balsa pen: shave one end of a piece of balsa wood.

Then cut the very tip away so that the edge is even.

(this is the very light-weight wood which is used for making models), which is about 3 cm (1·2 in) wide and 10 cm (4 in) long. With a sharp knife carefully shave one end so that there is a slight bevel, and then cut along the very tip to ensure that it is even. Cut v-shape notches in this end of the pen so that the end result in using the pen will be stripes. With a soft wide brush (a watercolour wash brush or clean home-decorating brush) paint along the drawn strip with the mixed paste and gouache, not worrying at all if you go over the lines. Use the balsa wood pen to create a wavy pattern in the paste mix before it dries. The paste in the paint prevents it from drying too quickly and also allows you to manipulate it with the pen. Allow to dry completely. Now mix up some silver gouache and use a ruling pen to write 'twenty five' in a free handwriting style over the wavy marks in the paste paper.

Black, white and silver strips are used to decorate the invitation, place name, menu and souvenir folder.

Depending on time available, you could make souvenir folders for the anniversary couple only, or they could be for everyone at the occasion. They contain a selection of photographs of the couple over the years which have been scanned into a computer and reduced to the same

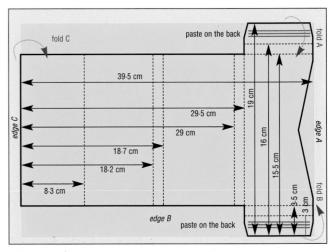

A 'keepsakes' folder for photographs and mementos for a silver wedding.

size. They provide an actual snapshot of their happy times together. Other mementos such as copies of their marriage licence and children's birth certificates (scanned and reduced as before) could also be included.

To make the folder, cut a piece of heavy-weight paper or light-weight card, at least 150 gsm, which is 39·5 cm (15·8 in) wide and 19·5 cm (7·8 in) long. Measure 29·5 cm from edge C and trim away 3·5 cm (1·4 in) from either side to leave two tabs which are 10 cm (4 in) wide and 3·5 cm (1·4 in) long. Measure 1·5 cm (0·6 in) from the outer edge of the tabs and taper them slightly at this point, as shown. Now measure and mark the midpoint along edge A, at 9·5 cm (3·7 in). Measure and mark 1·5 cm (0·6 in) from this edge. Measure and mark points at 4·5 cm (1·8 in) from both side edges. From these points, cut a slight v-shape tapering to the 1·5 cm (0·6 in) midpoint. This makes it easier to remove the contents of the folder. Now score lines at 3, 3·5, 15·5, and 16 cm (1·2, 1·4, 6·1, and 6·3 in) from Edge B. Score lines at 8·3, 18·2, 18·7, 29, and 29·5 cm (3·3, 7·1, 7·3, 11·4 and 11·6 in) from edge C. Bend over the folds and reinforce with the side of a bone folder. Run a line of paper glue or PVA along the underside on the diagram, but what will in fact be the top side of the paper on the tabs. Bend over and fold up on to the next panel, so that the folder is formed. Bend over fold C, and tuck it under the outer flap. It may help to run a line of glue at the outer edge to secure both parts of this flap.

Decorate the folder in matching calligraphy echoing the black, white and silver theme. The folder itself can be closed by a tiny square of matching or contrasting paper. Or you may prefer a ribbon closure. For this, select a width of ribbon which does not overwhelm your box and make two horizontal slits a little wider than the ribbon on the top flap and about 2 cm (0·8 in) apart. Ensure that you cut through the flap and its liner. Cut a 50-cm (20-in) length of ribbon and thread one end of it through the two slits. Place the photographs inside and wind the ribbon around the folder. You may need to adjust the lengths so that the bow is neatly positioned just below the slits.

The menu is made in the same way as the invitations and the same decoration is used for this and for the place names.

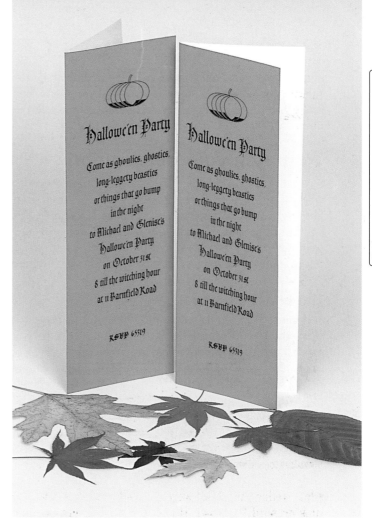

Ghoulies, ghosties and long-leggety beasties are all welcome at this Hallowe'en party.

A Hallowe'en party

Much less formal is a Hallowe'en party, and you can make the most of the spooky Gothic Black Letters for this occasion.

A theme of pumpkins decorates the invitation and envelopes shown above. The words have been written out as before – in lines according to the chosen style of script and design – and then pasted on to a clean sheet of paper for photocopying or scanning and printing.

Even adults do not mind silly party games, such as 'Bobbing for apples' and 'Murder' too much, at such an

occasion, so you could make a series of little bags for suitably themed prizes, such as joke spiders, plastic bats, black and orange jelly beans and hallowe'en candy (see photo below).

To match your celebration

If you are responsible as the designer for the theme of a celebration, then you can match not only the invitation, gift bag, souvenir box, menus, your own greetings card and envelope and so on, but also the wrapping of your own gift and even a souvenir picture frame for a photograph of the happy occasion along the same theme.

Gift wrapping paper

Wrapping paper is usually quite light weight, not more than about 100 gsm. This is because it needs to fold around a gift and anything that is too thick will not bend easily. Decorated A4-sized photocopying paper can be used for smaller gifts and A3-sized sheets of photocopying paper are useful for wrapping larger boxes and gifts. You can always paste sheets together with paper glue, ensuring that the join is not in an obvious place on the front or top of the package.

Wrapping paper to continue the theme of some of the celebrations in this chapter.

Gifts can be wrapped either in paper which continues the themes of this chapter, as shown above, or you could try something completely different. Here are some ideas.

Little bags containing prizes for party games at Hallowe'en.

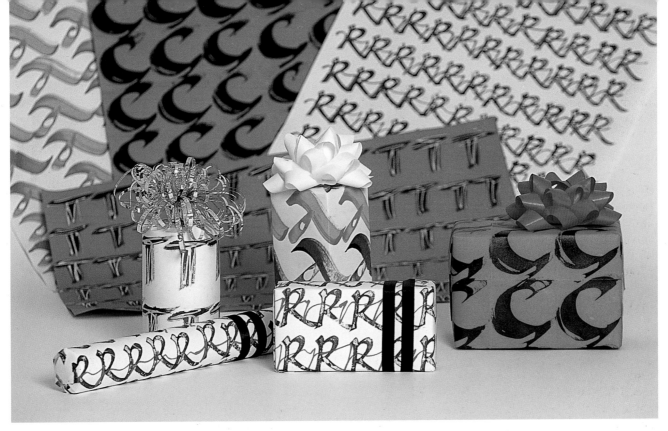

Hand-lettered gift wrapping paper makes any gift a delight to receive.

- Write out very free letters, minuscules or majuscules, using a wide home decorating brush or balsa wood pen. Go over the letters with a ruling pen (see page 6) filled with gold or silver gouache.

- Draw horizontal guidelines on a piece of paper. Cut a wide balsa wood pen to write the initial letter of the recipient's name repeatedly along the lines, with no gaps between the letters nor between the lines.

- Fold your paper into squares or rectangles, and use the fold lines as guides to write the initial letter of the person who is to receive your gift.

- Make a rubber stamp of the initial letter of the person's name. To do this select an eraser which is of a convenient size for the wrapping paper for the final gift (not too big for the gift, nor too small for you to work on). Draw round the eraser on a scrap piece of paper. Design a letter with two pencils or fine-pointed pens taped together, bearing in mind the final size of the eraser. Go over the lines of the thinnest parts of the letter to thicken them, otherwise they will not show at all on your stamp, it also makes it very difficult to cut. With a pencil trace over your design and place it on the outline of the eraser to ensure that it fits. Then place the tracing paper *face downwards* on the eraser, and go over the pencil outline to transfer it to the eraser. The image should be back-to-front on the eraser. Go round the outline of your design with a sewing needle the eye end of which is pushed into a bottle cork for ease of handling. Now use a sharp knife to cut away all the eraser which is not to be part of your design.

Either use a proprietory stamp pad or make your own. Mix up the colour of gouache which matches the ribbon to be used. Place a folded paper kitchen towel on a plate or saucer and pour the mixed gouache on to this. Press the rubber stamp on to the pad and stamp on a piece of scrap paper to ensure that the stamp is 'clean'. If there are any places where the eraser needs to be trimmed away then do so now. When the stamp is the best image, stamp over the paper either in a random pattern or in lines. You could add a contrast by writing over the letters with a ruling pen filled with a different coloured paint.

Making a photograph frame

Photograph frames are not at all difficult to make and, when they match the theme for a celebration, are a long-lasting memento of the occasion.

Decide first how large the photograph will be. In these frames, small photographs are often the best. When deciding on the proportions for a photograph frame remember that the top and two sides are usually about the same and the bottom margin a little bigger. This applies whether you have a portrait shape (longer vertically) or a landscape shape (longer horizontally).

These dimensions are for a small photograph of 5 cm (2 in) wide and 7 cm (2·5 in) long. Cut two light-weight pieces of card which are 12 cm (4·6 in) wide and 15 cm (6 in) long. One piece of card is for the back and to cover it cut a piece of light-weight paper (about 100 gsm or slightly less) which matches or contrasts with the paper of your design. The dimensions for this paper are 15 cm (5·9 in) wide by 18 cm (7·1 in) long. Place the cardboard back in the centre of this paper and draw round the outline carefully with a pencil. Now cut four bookbinder's corners (see page 98). Paste all over, place the card face down, turn it all over and rub over with a bone folder over a sheet of paper. Now turn to the back again and bend over opposite sides of the covering paper, rub over the side edge with the bone folder and push the side flap down. Tuck in the 'ear' at each corner and lastly bend over the top and bottom flaps, rubbing over again with the bone folder. Put this card to one side between pieces of baking parchment (silicone paper) and under a heavy weight such as a book.

Now cut out a rectangle from the front cardboard so that the photograph can be seen. Mark points which are 3·5 cm (1·3 in) and 10·5 cm (4·1 in) from the top edge and draw horizontal lines. Now mark points which are 3·5 (1·3 in) cm and 8·5 cm (3·3 in) from the left-hand edge and draw vertical lines. Using a sharp knife and metal straight edge, remove the rectangle from the centre.

Prepare the paper which is to cover the front of the frame. Cut a piece of paper which matches or contrasts your

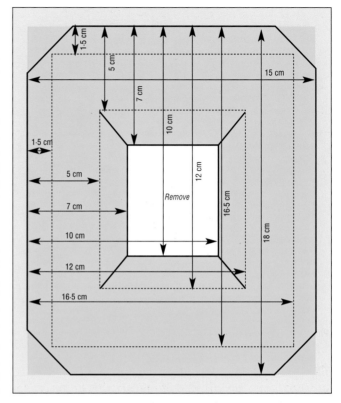

Covering paper for the front of the photograph frame.

final design and is 15 cm (6 in) wide and 18 cm (7 in) long. Place the front cardboard in the centre of the back of this paper and draw round the outline carefully with a pencil and then remove. Now mark points which are 1·5, 5, 7, 10, 12 and 16·5 cm (0·6, 2, 2·8, 4, 4·7 and 6·5 in) from the top edge and draw horizontal lines. Then mark points which are 1·5, 5, 7, 10, 12 and 16·5 cm (0·6, 2, 2·8, 4, 4·7 and 6·6 in) from the left-hand edge and draw vertical lines. With a sharp knife and metal straight edge remove the smallest central rectangle. Now cut diagonal lines from each of the four corners of the removed rectangle to the four corners of the next largest rectangle, as shown above. Take care not to go over the pencil lines. Place the paper face down and paste all over. Place the cardboard carefully on the paper, matching it to the outline previously drawn. Turn over and rub all over with a bone folder over paper. Place face down again on a clean piece of coated paper (see page 46) and turn in the

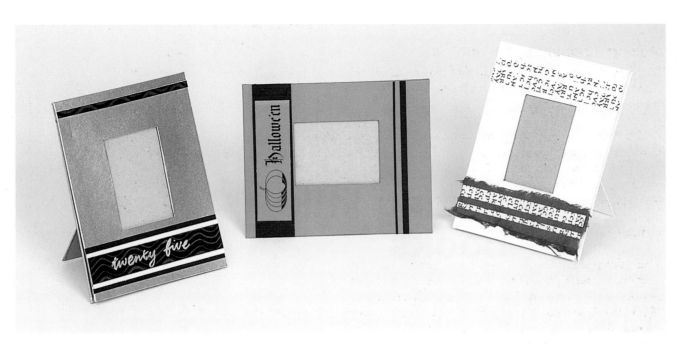

Photograph frames to match some of the occasions celebrated in this chapter.

flaps at the centre of the frame, taking care at each corner. Use the pointed end of the bone folder to ease the paper into the corners so that they are well covered. Now turn over the side flaps and then the top and bottom to make bookbinder's corners (see page 98). Place the covered cardboard between two pieces of baking parchment and under a heavy weight to dry flat. Decorate the front part of the frame to match your chosen theme.

Before the two pieces of cardboard are pasted together to make the frame, place them together ensuring that the covered sides face outwards. Now carefully mark the outline of the rectangle where the photograph is to go on the lower cardboard making sure that you do not get any pencil lead on the front cover. Remove the top cardboard and extend these lines using a pencil and straight edge on the bottom cardboard. Now place the photograph so that it is central top and bottom and side to side. Use a pencil to mark round it then remove. Cut strips of cardboard which will keep the front and back covers apart and also hold the photograph in place. These should be 1 cm (0·4 in) wide and 14 cm (5·5 in) long for the sides, and 5 cm (2 in) long for the base. On the back cover paste these

into position about 0·2 cm (0·1 in) out from the lines you have marked for the photograph. Allow to dry. Paste over the front of these cardboard strips and position the front of the frame carefully. Turn over and rub over with a bone folder from the back. Allow to dry.

To ensure that the frame stands up independently, make a support from a piece of stout card which is covered with the same paper as the back of the frame. Cut a piece of card which is 7·5 cm (2·9 in) wide and 13 cm (5·2 in) long. Mark and draw a horizontal pencil line which is 3 cm from the top and use the blade of a pair of scissors to score along it. Cut a piece of paper which is 10·5 cm (4·1 in) wide and 16 cm (6·3 in) long. Cut bookbinder's corners (see page 98). Paste over the paper and position the cardboard centrally on this. Cover as before. Now cut another piece of paper which is 10 cm (4 in) wide and 15·5 cm (6·1 in) long and paste this on the back. When dry, carefully ease and bend the cardboard support along the scored line. Paste the shorter section only of the back of the covered support so that you can carefully attach it to the back of the frame centrally from side to side and about 2 cm (0·8 in) from the top. When dry, bend the

writing little books

There is something about little hand-made and written books which makes them so covetable. Holding in your hand a book which has been designed so that the cover, paper for the text, decoration, style and colour of script and subject matter are all in harmony is a most pleasurable experience. This chapter will show you how to make these books, determine the size of script and the layout of the pages, and give you many ideas on how such books can be made individual, personal and unusual.

The charm of little books is that they are small, which means that to include a large amount of text requires a narrower nib rather than a wider one. It is probably better to select shorter texts at first until you are comfortable writing with a smaller nib, and leave longer poems and prose until you are confident of your writing and the construction of books.

Preparing the book

Having chosen your text, decide on the writing style, select a nib and rule up lines for x-height on layout or similar paper. Write out half a dozen lines either as separate lines of poetry or in continuous lines of prose. If the lines of poetry are long, you may choose to split them and possibly slightly indent the line following. For poetry and prose it is more comfortable for the reader if there are between six and nine words per line. Fewer than this and the eye has to keep jumping to the next line, more than this and the eye finds it difficult to maintain the level of the line. Count the words along the lines and determine whether you need to divide the lines of poetry, or where you should split the lines for prose. At this point, you may decide to go down to a smaller nib size if the size of the writing is overwhelming. Little books should be little, and not the size of a coffee table. Binding large books can be a challenge which it is best not to tackle until you are sure of the bookbinding techniques.

Having decided on the number of words per line and the resulting length of line, it is a good idea, if you have the time, to write out the whole poem or section of prose in rough at the required size. This way you will be able to identify any difficult word breaks – 'think-ing' rather than 'th-inking', for example – and adjust the text along the line very slightly to accommodate them.

Now determine the size of the pages. Allow for generous margins. Published books are often produced with very narrow margins due to production costs. Your book will have far fewer pages, and you will be able to cut many of them from one sheet of paper. Skimping will be a false economy because without good margins and quality paper, all the effort you expend on writing, decorating and binding your book will be spoilt by it looking pinched and mean.

1

To determine the dimensions of the text block:

1 Cut a piece of paper which is exactly the size of a folio – two pages – of your finished book. Fold it in half. Using a pencil and straight edge draw diagonal straight lines from the bottom two corners to the centre fold, and then from the bottom right-hand corner to the top left-hand corner.

2 Measure the length of one line of text (long enough for six to nine words). Mark this on the left-hand fold of paper, so that it extends from the one long diagonal to the shorter one – line A. This is the width of the block of text – the length of lines.

3 Draw a vertical line from the left-hand point where this line crosses the long diagonal to the point where it meets the short diagonal – line B. This is the depth of your text block – the number of lines.

4 Now complete the rectangle by drawing lines vertically and horizontally as shown. Copy the measurements from the top, bottom, side and inner margins so that the text block on the right-hand page is a mirror image.

2

If you have not written a book out before, then for your first few books adopt conventional margins and shape of book. This means that your book will be portrait (longer downwards) rather than landscape (longer widthways). Once you are familiar with layout and margins, then you can be more adventurous with your designs.

The margins for conventional manuscript books are that the top is narrower than the bottom margin and the two sides and middle (extending across the fold, or gutter) margins are about the same width. However, as you are not typesetting your book but writing it calligraphically, the right-hand margins will rarely be exactly the same, and so you will have to allow some lines to extend into the allowed margin and some will fall short of it. The diagrams on the left show how to work out the width of the margins, where the text should start and finish, and the number of lines on each page.

3

4

A book is esse-
ntially not a t

MITCHELL NIB 2½

A book is essentially
not a talked thing

MITCHELL NIB 3

A book is essentially not a
talked thing, but a written

MITCHELL NIB 4

Allow six to nine words per line for ease of reading hand lettering.

A book is essentially not a talked thing, but a written thing; and w communication, but of permanence. The book of talk is printed on speak to thousands of people at once; if he could, he would – the v of his voice. But a book is written, not to multiply the voice merely, preserve it. The author has something to say which he perceives to be beautiful. So far as he knows, no one has yet said it; so far as he know is bound to say it, clearly and melodiously if he may; clearly at all he finds this to be the thing, or group of things manifest to him;–th or sight, which his share of sunshine and earth has permitted him to

Write out prose in the best nib size and then mark on the line breaks.

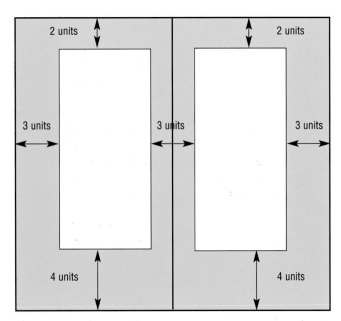

2 units

3 units 3 units 3 units

4 units 4 units

The conventional margins for a book are that the top margin at two units is half the width of the bottom, four units. The right and left side as well as the middle (gutter) are three units and therefore one and a half times the top measurement. These units can be any measurement – cm, mm, in, etc.

The amount of text you have allowed for on each page will now give you a guide as to how many pages you will need for your book. For a conventional manuscript book, the first page is often blank, or has a half-title written on it. It could be the dedication page if the book is a gift or to be presented to someone. The next page is then the full title. You may choose to write on the right-hand side only of the paper, or write on both sides. This depends on the length of your chosen text and how many pages you wish to include in your book. Each separate fold of paper will give you four pages. With these simple, single section bindings, you can include up to about eight folds of paper which makes 32 pages. Any more, especially if the paper is heavier-weight, will make the book too bulky, and you should refer to a specialist book-binding reference for multi-section binding.

If you have written out the complete text it is worthwhile making a paste-up at this point. Cut out pieces of paper which have the same dimensions as your planned book, fold them in half and mark on the outlines of the text blocks; number the pages. Place the pages together as though they were a book. Cut out the individual lines of calligraphy and paste them on to the pages allowing for dedication/half-title pages. Ensure that the lines are as long

Four folds of paper will make a 16-page book. Allow for the dedication or title page, and possible space at the back for a colophon, which is a note from the scribe to say who wrote the book and when.

You can use almost any paper for making books, as long as you can write on it. Conventionally, paper where the page just flops down when you hold a folio (folded piece of paper of the page size) in your hand at the fold is the best weight.

as planned and the spaces between the lines are not too wide nor too narrow, so that clashes are avoided. Now consider carefully the layout of the book. You may need to increase or decrease slightly either the spaces between the lines, or the length of the lines or the depth of the text block so that the chosen text fits comfortably into the number of pages. If there is only one line on the last page, then increasing the space between the lines or decreasing the depth of the text block will result in more lines on that page. Conversely, one or two lines after the last page of full text may mean that you have to include another complete fold (which makes four pages), and this could cause problems at the beginning of the book. Slightly decreasing the interlinear space will then mean that these extra lines can be absorbed into the rest of the book.

This may seem like a lot of effort, but it is far better to resolve any problems at this stage than to spoil expensive paper and your beautiful writing by having to write the last three words on the inside cover of the book because you overran on the previous page.

Choosing the paper

Almost any paper can be used for a manuscript book, from thin tissue paper to thick heavyweight paper. The only criterion is that you can write on it. You will be able to include more pages of a lighter-weight paper, and fewer of a heavier-weight paper in a single section book, because of the bulk of the latter.

If you want to start book making in a conventional way, cut a piece of paper which has the same dimensions as a folio (two pages) of your book and fold it down the middle. Hold the paper at the fold. If the page just flops over then this is about the best weight.

If you plan to write out a number of identical books then do ensure that you have sufficient sheets of paper to do so.

Before you mark the folio dimensions on the paper, or start cutting, determine the grain direction if the paper is not hand-made (see page 8). The grain direction must be parallel to the centre fold, otherwise you will have problems when you stick the cover on, or if the book gets damp.

of people at once; if he 2/1

could, he would–the vol-2/2

ume is mere multiplication 2/3

of his voice. But a book is 2/4

written, not to multiply the 2/5

voice merely, not to carry it 2/6

merely, but to preserve it. The 2/7

author has something to 2/8

say which he perceives to be 3/1

true and useful or help-3/2

fully beautiful. So far as he 3/3

knows, no one has yet said 3/4

it; so far as he knows, no one 3/5

else can say it. He is bound 3/6

to say it, clearly and melo-3/7

diously if he may; clearly 3/8

Paste-up of a double spread of the book below.

A simple, single-section book, sewn on to a slightly heavier-weight cover. The title does not have to be in large letters to stand out and make a statement.

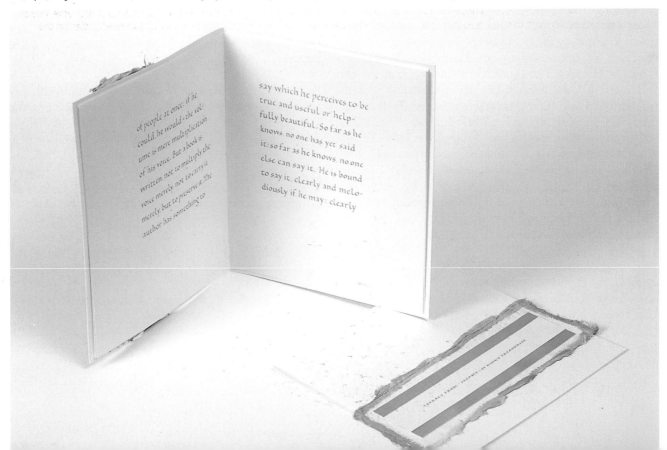

Writing the book

Having determined the grain direction of the paper, mark out the dimensions of the folios, ensuring that the centre fold is parallel to the grain. Now add about 5 mm (0·2 in) to the right and left sides. This will allow you a small margin to mark the positions of the lines of text, which you can trim off later. Cut out the folios carefully with a knife and straight edge.

Mark the centre fold with a pencil. Mark, too the positions of the top and bottom and the left and right margins of the blocks of text on each folio. If you use the point of a pair of dividers for this in your allowed tiny overlap space, then the pin prick will show through from one page to the next, and you can even do what medieval scribes used to do which is to square up three or four folios and push the sharp point through all the pieces of paper.

Use a set of dividers to gauge the width of the x-height of the pen nib you are to use. It is quickest to use another set of dividers to mark the distance between these guidelines.

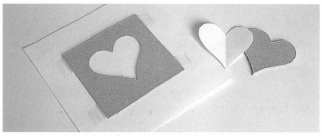

To emboss, cut your design – it could be an initial letter or a shape – from a piece of card. Retain the card from which the piece was cut, rather than the cut-out. Position this with tiny pieces of masking or magic tape on the *front* of the paper.

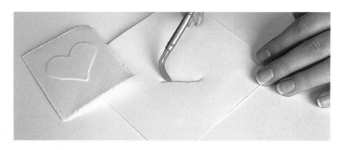

On the back of the paper use a bone folder, burnisher, or similar round-ended tool to push the paper through the blank. Carefully remove the card.

Written in calligraphy gouache which is mixed to match the colour of the cover, this two-verse poem to a husband is written in Italic on torn paper pages. It is sewn to the cover with matching ribbon, which ends in a bow on the outside of the cover, with tiny hearts attached to the ribbon ends. A decorative strip of spattered paper is overlaid with torn, red, hand-made paper, and then the same white paper used for the text with two hearts embossed to stand proud.

Transfer these measurements to the folios so that your lines extend from the top to bottom of the text block. If you have a drawing board with a sliding rule, you will need to mark these points on one edge of the paper only. If you do not have a sliding rule then mark on both the right- and left-hand sides. Draw lines as faintly as you can, using a 4H pencil, only between the right and left margins of the text block. If you draw lines completely from one edge to the other, then you will have to erase them and the paper can look very untidy if there is an indentation visible from the pencil line.

Even something as simple as a packet of coffee can be made into a very special gift. Here *Making Coffee* by William Ellis has been written out in Uncials using a mixed brown calligraphy gouache, the same colour as coffee. The paper was treated beforehand with random broad strokes of a much more dilute gouache in the same colour so that it looks like milky coffee. Both sides of the cover were washed in the same way, but with a stronger solution (stronger coffee!). It did not take long to prepare or write out, but this gift of coffee is memorable because of its association with this little book.

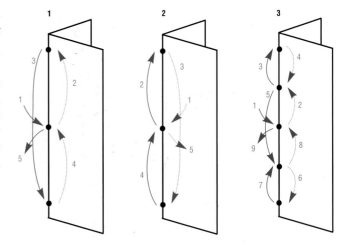

Sewing a single section book together:
1 Sewing for three holes, finishing on the outside.
2 Sewing for three holes finishing on the inside.
3 Sewing for five holes finishing on the outside.
Dotted lines indicate sewing inside the book.

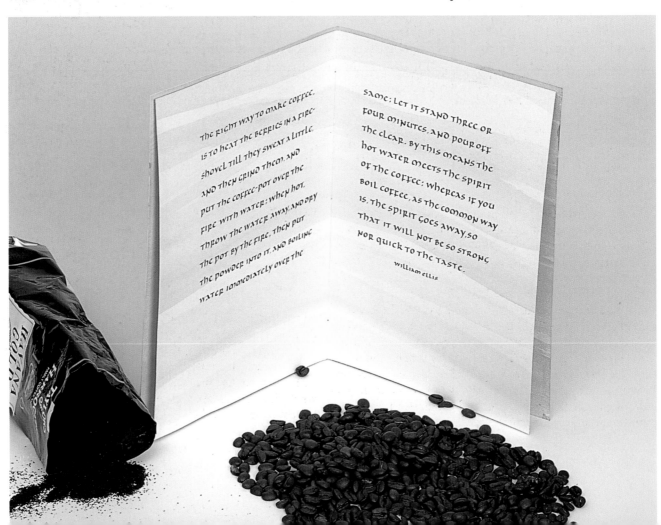

The right way to make coffee, is to heat the berries in a fire-shovel till they sweat a little, and then grind them, and put the coffee-pot over the fire with water: when hot, throw the water away, and dry the pot by the fire, then put the powder into it, and boiling water immediately over the same; let it stand three or four minutes, and pour off the clear. By this means the hot water meets the spirit of the coffee; whereas if you boil coffee, as the common way is, the spirit goes away, so that it will not be so strong nor quick to the taste.

william ellis

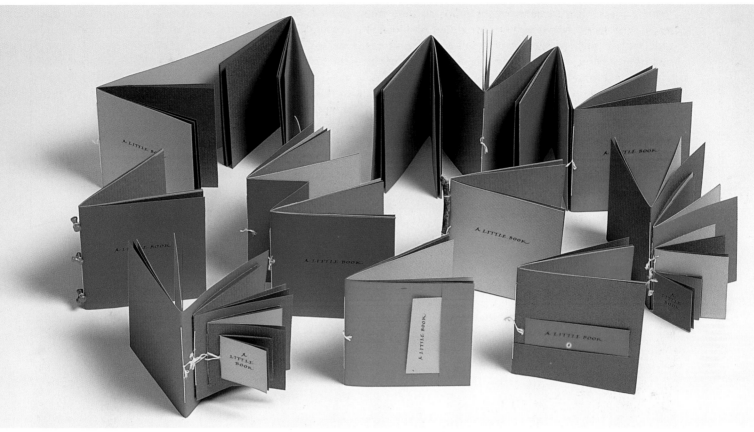

Single section books can be of many different shapes and sizes. Here are single section books sewn on to a strip of paper with a fold at each end, so the book looks like a mirror image, books sewn on to a zig zag (concertina of paper), and two books sewn together with a folded hinge. Increasing sizes of little books are pasted one on to the next, starting at the lower left-hand corner, and also placed centrally. One book has a turn up for the title to be written on a separate piece of paper (useful if you are not yet certain of your lettering) and tucked in, and another has a flap bent over at the front for the same purpose. Books are sewn on to a wooden twig at the spine, and also incorporate beads in the binding.

On another piece of paper, draw horizontal guidelines for x-height. Mix up calligraphy gouache to the consistency of thin, runny cream, sharpen your metal nib if necessary, and start writing on this piece of paper. Most scribes are slightly tense when they start to write, and it takes a few lines of calligraphy before they relax and loosen up. If you start writing in this state in the book itself, the words on the first page will probably be much tighter than elsewhere in the book, and the ensuing lines shorter. When you feel less tense, then start to write on the paper for the book itself. Write the whole book in as few writing sessions as possible; if you can, write it in one, although you should be aware of the need to stop now and again to let your muscles relax (see page 13).

Binding the book

The easiest books are those sewn on to a folded piece of slightly heavier-weight paper or card. If you wish to match the text paper to the cover exactly, then paste two or three sheets together to make it more robust.

Paper for the cover should be slightly larger all round than the book itself as it is there to protect the text pages. Add anything from 2 mm (0·1 in) to 1 cm (0·4 in) to the measurements from the top, bottom and two sides of the text pages, so that the margin extending beyond the text, when the book is open, is even all round. Carefully cut the cover out and fold it in half, reinforcing the fold with

a bone folder. Decorate the cover if you wish. The title can be written on the cover, or can allude to the text inside with a suitable symbol or small painting. If the book is to be given, you may prefer to write the recipient's name on the cover.

Place the pages in the correct order, ensure that the top and bottom edges are lined up and fold them over, matching up the right and left edges. Use a bone folder to make the fold. Even if your book consists of only two folios, you will probably find that the inner pages protrude more than the outer pages. This is certainly true with thick paper, or with more pages. Use a knife and metal straight edge to trim off the excess, holding the pages securely while you cut. This makes a neater fore-edge.

Place the text pages inside the cover, and position them so that there is an even margin all round inside. Use plastic paper clips to keep the pages and the cover together. With a straight edge and pencil mark the midpoint along the spine. Depending on the size of the book, you may choose to have only two more points marked along the spine,

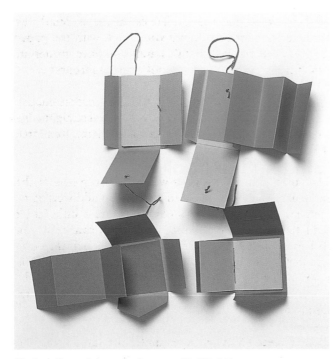
Single section and zig zag books encased in little folders.

one each side at an even distance from this (three hole sewing), or you may choose to have four more points marked (five-hole sewing). The point nearest to the top and bottom of the book (head and tail) should be not too close to the edge, otherwise the top and bottom margins of the paper may be weakened, but not too close to the midpoint, otherwise the sewing will not give it strength.

Open the book out and place on a cutting mat or piece of old cardboard. From the outside of the book, push a needle – with its eye end held in a cork for safety – right through the pages at each marked point. Try not to let the cover and pages crease as you do this.

Decide whether you want the bow or knot on the inside or outside of the book. Use embroidery silk, narrow ribbon, bookbinder's linen thread, raffia, or whatever you think will enhance your book. Start to sew where you want to finish, following the sewing pattern shown on page 92. Make sure that the needle is pushed straight through the paper; if it is at an angle it may tear when the thread is pulled tightly. Finish with a neat bow or knot. Fray the ends of the thread with the flat of the needle if you wish.

Variations on single section books

Once you have the technique of making and sewing single section books, you can make them in different shapes and sizes, and with a variety of covers, using all the techniques of decoration shown in this book. Look back at page 93 for some ideas.

Zig zag or concertina books

These little books are fun to make. Treat them as separate pages if you wish, or as one long, continuous canvas for your writing and decoration.

Use paper that is about 150–200 gsm for the text pages. Paper that is too flimsy will not withstand the opening and closing of the zig zag, especially where the folds are prominent at the front, and paper that is heavy-weight is difficult to fold and hold secure.

Zig zag books should have an even number of pages and an odd number of folds. Select your text and experiment

with lettering style, size of nib and layout. Generally, each page of a zig zag book is regarded as having its own identity, unless you plan for the whole book to be as one, or for opening folds to be similar to an opening spread for a book with a spine.

Calculate the sizes of each page and how many pages you will need. Remember to add the title page, and dedication page if it is to be a gift, and possibly a page for the colophon (scribe's note at the end of the book). Determine the grain direction of the paper (see page 8) and cut out a strip of paper for your book where the grain is parallel to the folds. You may need to add additional strips of paper to make your book the required length. To do this, allow for a very small overlap of about 1 cm (0·4 in). Faintly, in pencil, mark on the measurements for the separate pages and draw vertical lines along the folds. If you need to add additional strips, ensure that the paper allowed for an overlap goes behind a 'valley' fold or back fold, rather than at a 'hill'. There will be less wear and tear here and the paper will stay attached for longer (see page 96).

Now mark on the the guidelines, again as faintly as possible. It is easier to write your book with the paper flat, so leave making the folds until you have written it. Add any decoration to your book when appropriate.

When you have finished the writing and decoration, use the pointed end of a bone folder and a metal straight edge to score along the folds, and then crease them. Reinforce the folds with the bone folder.

The cover may be a heavier-weight paper, pieces of the same paper as the text pasted together to add weight, or matching card. Cut two pieces which are a little larger than the dimensions for the pages. This can be 2 mm (0·1 in) all round up to 1 cm (0·4 in), although the book would be quite large to need that amount of margin. The grain direction should again be parallel to the folds. Mark the grain direction on the inside of the covers. Decorate or letter the covers if you wish.

Place a piece of scrap paper under the last fold at the back of the book. Brush PVA or bookbinder's paste all

Experiment with the decoration, if you wish, on zig zag books. Here this extract from Katherine Mansfield's *Garden Party* was written out in different ways, three of them using ideas suggested by the text itself. First, with the lines well spaced, at the top, and then, taking inspiration from the text, with a line of short, cut grass made by different shades of green pencil. The next with a single rose on each page emphasizes that a design may look acceptable with a paste-up, but when it is actually written out, it may need adjusting, as here the position of the rose is too low. Lastly, the design chosen, where Conté pastel has been used to add colour reflecting the green grass, the blue sky and 'the haze of light gold'. The dry pastel was scraped with the back of a knife to make powder and this was dabbed on with cotton wool after the writing had been completed.

Any additional paper strips should be pasted under a back fold.

over this last page, and place the back cover on top, checking the grain direction. Remove the scrap paper immediately, and slide the page so that it is in the centre of the cover. Place another piece of clean scrap paper over the inside cover and rub over with a bone folder to distribute the paste evenly. Now put a piece of silicone paper (baking parchment) between the pasted cover and the next page of the book and allow to dry under a weight. This may take a couple of hours. Repeat for the front cover.

You can make card covers covered with matching paper or fabric. To do this select a suitable weight of card for your book and cut two covers which are slightly larger,

as before, with the correct grain direction. Now cut two pieces of paper, with matching grain direction, or two pieces of fabric, which are both 2·4 cm (1·8 in) larger all round than the card covers. (Smaller covers require less overlap.) If you are using fabric it is often best to paste this on to a piece of 80 gsm paper before attaching it to the card cover. Position the cover evenly on the underside of the paper or fabric, and mark the edges with a pencil. Brush PVA or paste all over the paper or fabric, and place the card immediately on top. Turn over, place a piece of scrap paper on top and rub over with a bone folder. Turn back to the underside and cut bookbinder's corners on each corner (see page 98). Re-paste the sides and fold over those opposite; tuck in the 'ear' with the point of a bone folder and then fold over the top and bottom. Attach to the book as before.

You may prefer to have some sort of fastening for these zig zag books, as otherwise the books fly open when not in use. Fastenings can be ribbons pasted to the back cover before attaching it to the book pages; the ribbons are then tied on the front cover in a bow. Or you may choose a simple strip of paper which is folded around the book and the ends pasted together; this slides off the book when in use. If the book has lighter-weight covers, you can punch a hole when the book is closed through the covers and the book itself, thread a narrow ribbon through all the holes and this can wind round the book and tie in a bow for security.

The finished zig zag book.

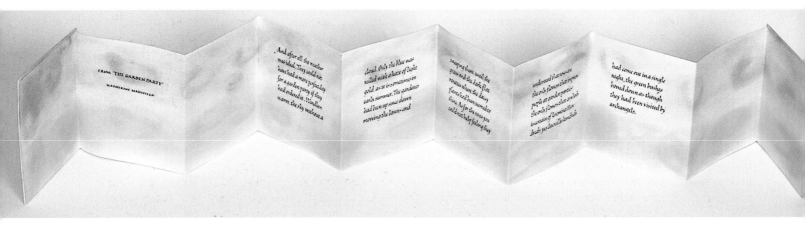

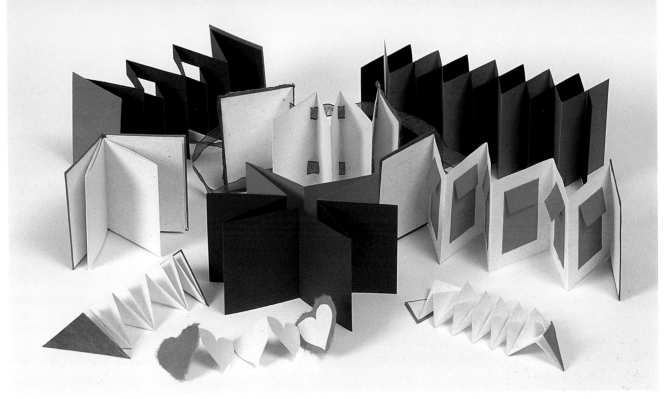

A variety of zig zag books. Top left the pages of the book have been cut horizontally and the folds reversed, to the right, just in front of that ribbon has been threaded through slits cut in the pages and cover, and to the right at the back, two separate folds are slotted together after vertical slits were cut in the bottom half of one fold and in the top half of the other. In the middle left a hard-backed cover contains not separate pages but a zig zag, in the centre the two ends of a red fold and a purple fold have been pasted together to make a star shape, on the right, tiny envelopes were pasted on the folds, allowing a series of secret messages, or perhaps a suspense story to be inserted on pieces of paper. In the front on the left, a triangular book made from an equilateral triangle, in the middle a lover's book made of heart shapes, and on the right another triangular book but this time of an isosceles triangle which results in a fascinating pattern of folds.

Hard-backed books

The method of construction of these books is slightly more complicated but the end result can be so much more satisfying. These books have text pages which amount to a single section which is then bound between covered cardboard with a spine. If you want to write a book which has more sections, refer to a specialist text for sewing it together.

Prepare the paper as before, but ensure that you have a blank first and last page as these will be pasted to the end-papers, and write out the text. Before you sew the book together you will need to include two pieces of patterned paper for the end-papers. The pattern means that bumps from the turn-ins of the covering paper are not so obvious. Choose a paper which has a small pattern, or make patterned end-papers yourself by spattering paint (see page 48), using a paste-paint mix (see page 79),

clingfilm (saran wrap) wash (see page 45), a salt wash (see page 64), sponging (see page 67) or what you will. Check that the grain direction is parallel to the spine.

The two end-paper pages are obviously at the ends of the book, and, importantly, they should be placed facing one another, with the patterned sides together. Add these to your book and square up the pages as before. Sew the pages together including the end-papers using three- or five-hole sewing (see page 92) and beginning outside the book, so that the knot cannot be seen when covered, and then trim off the fore-edge.

Now place a piece of scrap paper between the last page of the written book and the rest. Paste all over and place the closest end-paper over it. Remove the scrap paper and replace with another piece. Rub all over with a bone

Making a bookbinder's corner.
1 Cut a generous diagonal across the corner.
2 Turn over the fore-edge or side fold and press down.
3 Use the point of a bone folder to press down the little 'ear'.
4 Turn over the head or tail (top or bottom) edge and press down with a bone folder to make a neat covering.

folder, replace the scrap paper with a piece of silicone paper and allow to dry under weights. Repeat this operation for the front of the book. Put to one side.

The cover should now be constructed. Select card of a suitable weight for the size of the book and check the grain direction (see page 8). Cut two pieces of card which are 2 mm (0·1 in) larger at the top, bottom and fore-edge and where the grain is parallel to the spine; mark the grain with an arrow. Cut another piece of card for the spine which is the same height as the cover, and the depth of your book plus about 2 mm (0·2 in) either side. It is difficult to be specific here because a tiny book with very thin card covers will require a narrower spine and a book with thick paper and substantial covers will need a thicker spine.

Now select the fabric to cover the book, matching it to the chosen colour of the text or theme of the book. Closely woven fabric is best with a small pattern; that used for quilting is ideal. Fabric with large patterns or designs can overwhelm a small book.

Place the two covers side by side with the spine between them, with a gap of about 2 mm (0·1 in). Cut a piece of fabric which is 3·2 cm (1·3 in) longer than the height of the covers and twice the width of one cover, plus 3·2 cm (1·3 in) plus the width of the spine and the allowed spaces. It is also recommended that you paste a piece of paper on to the underside of the fabric. This prevents any adhesive

Page 99: Stages in making a single section hard-bound book:
1 Sew the book together including the end-papers.

2 Paste one end-paper to the first page of the text pages and the other end-paper to the last page of the text pages. Put to one side under a weight.

3 Cut the covering material and card to size for the cover.

4 Mark up and paste the covering material to the card cover.

5 Make the cover.

6 Paste one end-paper and attach it to the back cover. Repeat for the front end-paper and cover.

7 Place under a weight until completely dry.

8 The finished book.

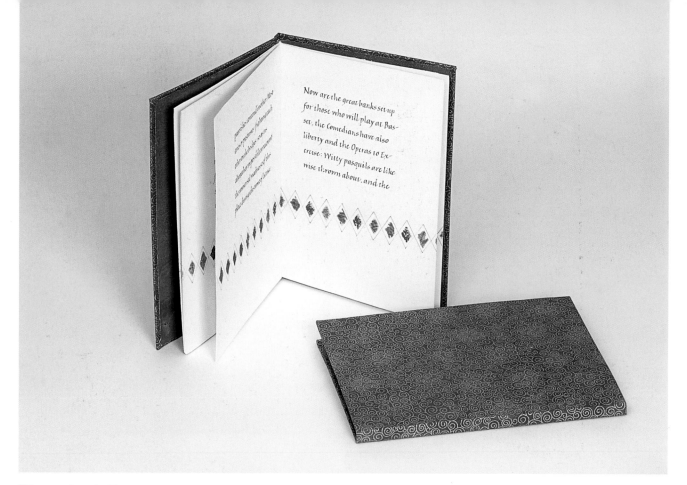

This extract from the *Diary of John Evelyn* is about the Carnival in Venice. A suitably decorated fabric was chosen for the cover and this matched the salt-wash end-papers. Black Italic lettering (after all, Venice is in Italy!) was used for the text and a decoration in the lower margin acknowledges the diamonds of a Harlequin and purple-sponged lozenges, the shape of the decoration on many of the Venetian buildings.

oozing out while binding the book. Cut a piece of paper about 80 gsm in weight which is slightly larger than the fabric with the grain direction of the short side parallel to the spine. Paste all over the paper, place the fabric on top, the underside against the paper, and rub over with a bone folder over scrap paper. Try to avoid any creases. Allow to dry. Trim away the excess paper.

Place the fabric face down, and with a pencil and straight edge draw a horizontal line which is 1·6 cm (0·65 in) from the top. Now draw vertical lines which are 1·6 cm (0·65 in) in from the right and left edges. Place the card for the cover so that the left-hand cover matches the horizontal and vertical lines on the left and the right-hand cover on the right. Place the spine evenly between them and draw around the outline of it. Remove the card.

Paste all over the underside of the fabric cover (which will be the adhering paper) and place the card covers and spine in position, ensuring that the grain direction is parallel to the spine (take special care if the covers are square) and that they match up to the drawn lines. Turn over and rub it all over with a bone folder over paper. Cut bookbinder's corners (see page 98), re-paste the sides and turn those over, rubbing over with a bone folder, tuck in the little 'ears' and then paste the head (top) and tail (bottom), turn in and rub over with a bone folder. Allow to dry under a weight.

When dry, bend the cover into position. There should be enough fabric making a hinge to allow the covers to close easily. Place the book inside. Choose the best side of the cover and make that the front. Mark *f* on the front cover

A variety of ways of binding single section books. On the left at the back, the book has an additional flap which encases the text pages. On the right of that, the book is closed by a matching fabric loop and bone tag. On the far right is a book which has a paper folder on the back page in which photographs or loose-leaf material can be placed. On the left at the front the book is closed by ribbons wound round the cover, and next to it the book has a fabric spine and the rest of the book cover is paper. The last book is closed by ribbons at the fore-edge which have been threaded through slits cut into the fabric cover before binding.

and make sure that this matches the front of the book, and *b* on the back cover and of the book.

Have all the materials to hand and go through this process first as a 'dry run'. When you are sure of the procedure then apply the paste. Place a piece of scrap paper between the last page of the book, which is an end-paper, and the rest of the book. Paste over this. Position the end-paper on the back cover, matching the spine to the spine edge of the cover, and slide it so that there is an even amount of top, bottom and side cover showing. Rub over with a bone folder over paper. Insert a piece of silicone paper between the end-paper and the rest of the book, close the book and allow to dry under a weight. Repeat this for the front. Allow the book to dry for a couple of days under a weight with silicone paper between the card cover and the text pages of the book to avoid the covers curling.

poetry and prose

Calligraphy is mainly about words, and one of the joys of calligraphy now you are able to write different alphabet styles is that you can create beautiful pieces to hang on your own wall or to give as gifts to friends and family, with text specially selected just for them. You may have favourite poems or sections of prose which you already have in mind to write out, or you may read or hear a text in the next few weeks which will inspire you. This chapter will show you how to choose a calligraphic writing style, how to make some words into a contrast and how to introduce simple uses of texture and colour to make something of which you can be proud.

Selecting the text

Some panels of calligraphy, broadsheets, are made to hang on the wall; it is best, therefore, to limit the amount of text used as the readers will be unlikely to stand and plod their way through a short story. Longer sections of poetry or prose are probably best presented in book-form, as shown in the last chapter. However, calligraphic broadsheets can combine texts of different lengths from various sources on a related topic.

Selecting text is not difficult if you enjoy words. You may remember poems or quotations from many years ago, or you may be choosing a section of prose which is appropriate for a friend or relation. Many people are moved by selections of readings chosen for an occasion such as a wedding, anniversary, birth celebration or funeral. All of these can give you the inspiration for creating a piece of calligraphic artwork. It is a good idea, early on in your calligraphic career, to start to collect poems and sections of prose which appeal to you, or which you think would be appropriate to be written out at some point in the future. If you eventually aim to be a professional scribe you then have texts suitable for your clients to choose.

However, it should be pointed out that if any of your artworks are sold or printed and the words are not your own, then copyright regulations may apply. Do check with those for your country, as authors have a right to benefit if their words are sold for profit in the same way as calligraphers. In Europe the copyright regulations do not apply if the author died more than 70 years ago, in the USA the ruling is for 75 years from the time of first publication. However, there may be beneficiaries who still have an interest, and if words have been translated then the translators can benefit if they are still living or died fewer than 70 years ago. This does not mean that you can only write out ancient or historical texts. Many modern authors are delighted to have their words presented in a calligraphic way. Write to the publisher of the text asking for permission to use the words in your calligraphic work, offering to pay a small fee, and present a copy of your artwork to the author as an thank you for their agreement.

QUANT E BELLA GIOVINEZZA
How beautiful is youth

CHE SI FUGGE TUTTAVIA!
that is always slipping away!

CHI VUOL ESSER LIETO, SIA:
Whoever wants to be happy, let him be so:

DI DOMAN NON C'E CERTEZZA.
about tomorrow there's no knowing.

LORENZO DE' MEDICI

This Italian text with its English translation is brought into sharp contrast with the use of colour and two different writing styles, Italic and Roman Capitals which have been given a slant and a degree of movement. The free initial *Q* marks the start of the poem, the author's name is written in tiny majuscules, and the dancing gold squares towards the base of the piece add interest. This was completed for friends' joint fiftieth birthdays – hence the five large gilded squares each representing ten years – they have three children – the medium-sized squares, and the smaller squares simply completed the design. This would not be difficult to replicate for other birthdays, but endeavour to achieve a balance in the positions and directions of the squares.

How to start

Once the text has been selected, the next stage is not difficult. You will need to consider the following:

- Colour. Does the piece suggest a particular colour scheme to you – calm, peaceful words perhaps should reflect restful colours, possibly in the blue/green register, whereas a lively vibrant text may call on colours such as yellows and oranges or reds and purples. Is colour to be introduced in the lettering only or is the paper to be coloured too, or is a background wash perhaps with a texture to be a consideration as well?

Is the piece to hang in a particular room which has a definite colour scheme which should be taken into consideration? You may want to tone down your loud exciting piece if the decoration surrounding it is very quiet and subdued, otherwise it may seem to jump off the wall more than you would wish.

- Size of lettering and of the finished piece. These two aspects are related. The size of lettering for pieces to hang on a wall is usually larger than that for the little books which are held in the hand, as most people read calligraphic broadsheets standing a little away from the piece. Consider the nib size you are most comfortable using. If you are not yet happy with a smaller nib, then use a larger one, and perhaps reduce the amount of text.

One of the most frequent problems when beginners start to write out calligraphic pieces is that they try to fit them into frames which they already have, and those frames are usually very small. Calligraphy needs to breathe; try not to skimp on paper, nor on margins surrounding your work. If your intended frame is small, reduce the number of words perhaps to simply one poignant phrase.

- Style of lettering. If you have learnt the historical lettering styles in this book, you will have four very distinct alphabets from which to choose. Each suggests a different atmosphere, and it can enhance your piece to match it to the selected words. Gothic Black Letter suggests a mediæval feel to many, Uncials are grand letters, English Caroline Minuscule (Foundational or Round Hand) is formal, and Italic, despite its use in the Renaissance, looks modern and lends itself to flourishing.

For three of these styles, there is also the contrast between majuscules and minuscules, although it should be pointed out that Gothic Black Letter

majuscules are very difficult to read when written as text and are best avoided. There is also the contrast between lettering styles to consider, for example, you may wish to use one hand for the text and another for a translation or contrast. A word of caution, however, is that it is best not to mix too many different writing styles, minuscules and majuscules, otherwise the finished piece looks rather confusing.

- Elements. You may have talents which you are longing to incorporate with calligraphy – flower painting, watercolours, pen and ink drawing and so on. Calligraphy is an important element on its own, and you need to decide early on which is to take prominence. If the words are important to your finished artwork, then any decoration or addition should take second place. A background wash with a texture, detailed botanical paintings, lettering of different styles – majuscules and minuscules – and in a variety of colours may not achieve the effect you really want. Until you are sure of how lettering can be used, try to restrict your design to about three elements. A textured background wash, majuscules and minuscules in one hand and perhaps two colours will probably look about right. A small pen and ink drawing, lettering in one writing style and in two colours will also probably balance well, although it may be tricky to gauge the size of the drawing and that of the calligraphy until you have experimented with both.

Once these aspects of the finished piece have been considered, select your pen nib and draw guidelines. I find it best to write out poetry first in the lines decided by the poet and prose on lines as continuous text. This then gives me a basis from which to work.

Designing the piece

Having written the words out in one size and writing style it is best to photocopy them so that you can work with the photocopy and cut it up, retaining your original calligraphy. If you change your mind completely and have cut up the original, then it may cause you more work.

On a large sheet of layout or similar paper, draw a vertical centre line if the piece is to be centred or about a

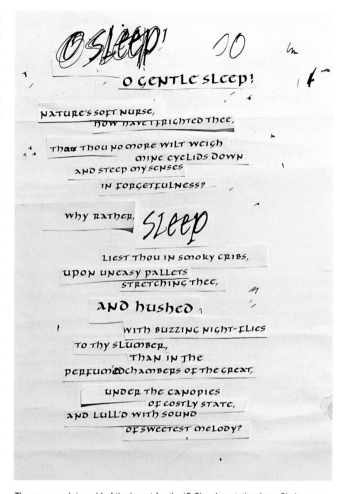

The very rough 'rough' of the layout for the 'O Sleep' quotation from Shakespeare on page 22. The words were written out on layout paper, and then pasted on to a larger sheet. 'O Sleep' and 'Sleep' were written again with a ruling pen and the lines adjusted accordingly. 'O gentle sleep' and 'And hushed', written in a larger nib size, adds another element of contrast. Marks around the paper are where I got the pen to work when transcribing the lines. Experiments were made with the washes. I wanted to create an idea of a centre of calm surrounded by busy-ness and unrest. The grey is a favourite, a combination of ultramarine and a mixed warm brown (either mix a colour or use burnt Sienna from a tube of gouache).

central axis, or a vertical line on the right – if right aligned – or left – if left aligned. Cut the words into strips which are the length of the line of poetry, or where you think the natural pauses will be for prose; where there is punctuation is a good start here. Number the strips with a coloured pen or pencil as you do this so that you are

1

one, two, buckle my shoe,
three, four, knock at the door,
five, six, pick up sticks,
seven, eight, lay them straight,
nine, ten, a big, fat hen.

2

one, two,
buckle my shoe,

three, four,
knock at the door,

five, six,
pick up sticks,

seven, eight,
lay them straight,

nine, ten,
a big, fat hen.

3

ONE TWO
buckle my shoe,

THREE FOUR
knock at the door,

FIVE SIX
pick up sticks,

seven eight
lay them straight,

nine ten
a big, fat hen.

4

ONE TWO
buckle my shoe,

THREE FOUR
knock at the door,

FIVE SIX
pick up sticks,

SEVEN EIGHT
lay them straight,

NINE TEN
a big, fat hen.

The stages in creating a broadsheet. **1** First the words were written out in rough in the same pen nib size. **2** This was photocopied and the words cut into strips. **3** The design seemed rather dull at this point, so experiments were made with different styles of *one, two, three, four.* The strips were then placed on a large sheet of paper with a centre vertical line. Which worked best? I had decided on the colour scheme of blue and green for a child's bedroom, but the piece still did not hang together. **4** Finally, a wide painted vertical stripe, made by moving the brush slightly from side to side as the line was painted provided the necessary key. The lines were finally written to form a central design once powdered gum sandarac had been applied to the painted stripe.

aware of their order. Place the strips on the large sheet of paper. If your work is to be centred, then fold each line in half, matching up the letters at the beginnings and ends of lines so that the fold is in the middle, and use this. Attach a tiny piece of Magic tape to either end of the strips to keep them in place.

Now stand back and look carefully at your work. Pin or attach it to a wall if you can. The lines may well work together perfectly as planned in your mind, or you may wish to add another element. Are there any words or phrases that stand out to you? You could decide to write these in a larger or smaller nib size (smaller is a contrast to the rest of the text, so it will stand out, especially if there is a lot of white space around it). Or you may introduce majuscules or a different writing style here. Remove the words or phrases to be rewritten, keep them, as you may change your mind, and insert the newly written ones. Lines may now need adjusting to take into account the larger or smaller size strips of words. Look again at the section on page 26 on Layout and Design to see ways in which your lettering may be improved. When you are satisfied with the final layout, use a pencil and straight edge to draw a central vertical line over the strips, so that you have this as a reference point on each.

If you are to introduce more elements, then these should be done now. Coloured paper, a coloured or textured wash, colour in the pen, watercolour painting, all affect the balance of the lettering, so experiment and try these out at this point. If you are not used to working this way, it may seem to be a lot of bother when all you want to do is to write out some words. Take the advice of someone who has learnt from experience, and who is essentially quite impatient. Time spent now will save you hours of wasted time when the end result is unbalanced, overwhelmed by a heavy wash, the colours clash or when the words and decoration simply will not fit into the space allowed.

If you are a little unsure of using colour in your pieces at first, then choose a suitable coloured paper and use coloured paint (see below). Start by adding extra emphasis or contrast with coloured pencils in tiny strokes so that the colour looks more solid. Alternatively you can use powdered pastel crayons. Scrape these with the back of a knife and apply with a piece of cotton wool (see illustration opposite).

As your confidence increases, you can then explore coloured paint in the pen and as washes.

Using colour

Some calligraphers feel very safe using only black ink and white paper, perhaps with a touch of red. This is understandable. After all, this was the scheme used for hundreds of years in mediæval manuscripts. This was also the time when scribes and artists had to grind their own pigments and mix them with an adhesive such as egg to make them stick. Nowadays we can buy tubes of ready-mixed paint from art shops in a whole variety of colours, tones and shades. Many poems or sections of prose suggest a colour – green and brown for nature, blues and greens for the sea, red for anger or a Valentine's Day quotation, pastel colours for gentleness and softness and so on. And this is just for the colour of the ink; there is then the colour of the background or the possible accompanying washes. Not everything suits being written in harsh black ink on white paper. It is a pity not to use the tremendous range of colour to help express the meaning of the words used for your calligraphy.

Standing in front of the full range of a gouache paint manufacturer's display when you are new to colour can be very daunting. Where do you start and do you ever finish until you have every tube? Is one red better than another? Which green works best in the pen? Do you have to buy different types of paints if you want to make a wash?

Fortunately, colour is quite simple. For calligraphy, gouache paints are best as most are opaque and so cover the pencil guidelines that you will need for your letters. Watercolour is transparent and does not do this. One paint manufacturer now produces gouache specially for calligraphers. The pigments are strong and very finely ground and when mixed with water they pass easily through the space between the nib and the reservoir. Some artist's gouache can be of good enough quality, but

some of the individual colours can be greasy or gritty. Designer's gouache was originally made for those who usually presented their work to clients. This did not need to last very long, so is often not lightfast after about six months. You may want your work to last longer than this.

It is best to buy the highest quality gouache that you can afford. This will not be a waste. Calligraphers use very little paint, and tubes will probably last you many years. Better quality paints do not harden in the tube so quickly, and thus last longer.

For the whole of your calligraphic career you will need only six colours together with black and white. These colours are given on pages 108–09. Every other colour can be mixed from these six – two blues, two reds and two yellows.

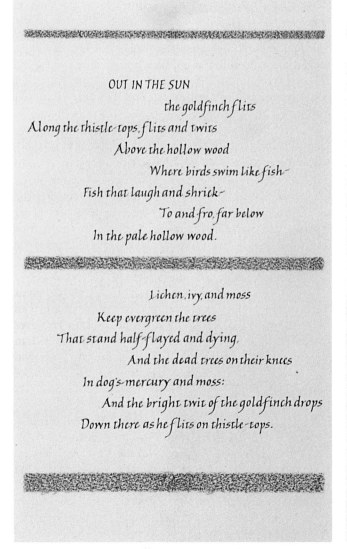

OUT IN THE SUN
the goldfinch flits
Along the thistle-tops, flits and twits
Above the hollow wood
Where birds swim like fish—
Fish that laugh and shriek—
To and fro, far below
In the pale hollow wood.

Lichen, ivy, and moss
Keep evergreen the trees
That stand half-flayed and dying,
And the dead trees on their knees
In dog's-mercury and moss:
And the bright twit of the goldfinch drops
Down there as he flits on thistle-tops.

Start by using colour in the pen, in the paper, and here as coloured pencils applied in tiny strokes to give an overall impression of a block of colour.

BRIGHT CLOUDS OF MAY
SHADE HALF THE POND.
BEYOND,
ALL BUT ONE BAY
OF EMERALD
TALL REEDS LIKE CRISS-CROSS BAYONETS
WHERE A BIRD ONCE CALLED,
LIES BRIGHT AS THE SUN.
NO ONE HEEDS.
THE LIGHT WIND FRETS
AND DRIFTS THE SCUM
OF MAY-BLOSSOM.
TILL THE MOORHEN CALLS
AGAIN
NAUGHT'S TO BE DONE
BY BIRDS OR MEN.
STILL THE MAY FALLS.

Coloured pencils and powdered pastel crayons, as used here, have an advantage because they have been applied after the lettering.

colour and colour mixing

Most people know that there are three primary colours of red, blue and yellow from which all other colours can be mixed. Why is it, then, that red and yellow do not always make that vibrant singing orange that you wanted, and that red and blue often make a dull magenta and not a royal purple? This is because the colours you are mixing are not pure, and each contains a little amount of other primaries. A lemony yellow, which contains quite a bit of blue, when mixed with an orangey-red will make a mix not solely of yellow and red, but also with blue from the yellow. Mixing all three primary colours together in this way means that it is not a bright orange but a dull orangey-brown. Similarly, that same lemony yellow mixed with a bright ultramarine, which has red in it to make it a warm colour, will not make a bright, spring green, but a dull olive, because red from the ultramarine is mixed in with the blue and yellow.

Rather than simply three primaries, the colours of blue, yellow and red can be further divided into six:

blue tending towards red – blue-red
blue tending towards yellow – blue-yellow
yellow tending towards blue – yellow-blue
yellow tending towards red – yellow-red
red tending towards yellow – red-yellow
red tending towards blue – red-blue

Good secondaries can then be made by mixing together the two sub-divided primaries which are linked. So the blue-red mixed with the red-blue will give a good purple. The yellow-blue mixed with the blue-yellow will give a good green, and the yellow-red with the red-yellow will result in a good orange.

Similarly, mixing the unconnected colours will give less vibrant and somewhat dull colours.

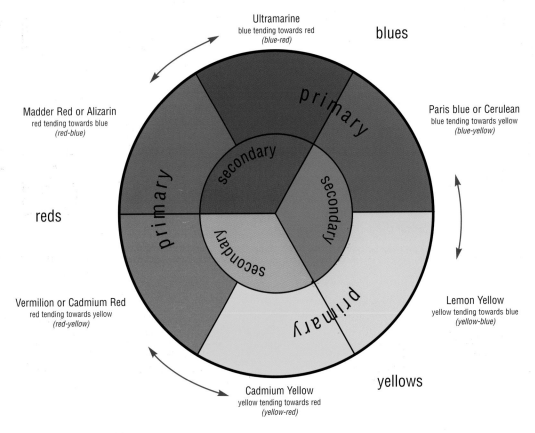

Ultramarine
blue tending towards red
(blue-red)

blues

Madder Red or Alizarin
red tending towards blue
(red-blue)

Paris blue or Cerulean
blue tending towards yellow
(blue-yellow)

primary

secondary

reds

primary

secondary

secondary

primary

Vermilion or Cadmium Red
red tending towards yellow
(red-yellow)

Lemon Yellow
yellow tending towards blue
(yellow-blue)

Cadmium Yellow
yellow tending towards red
(yellow-red)

yellows

Although you may now think that instead of buying three tubes of paint in red, blue and yellow, you now, annoyingly, have to buy six, these six colours will mean that you can mix any other colour you want to and are the only ones you have to buy, once you have understood and appreciated this colour mixing.

The six basic colours then are:

> *Ultramarine* – blue-red
> *Paris Blue* or *Cerulean* – blue-yellow
> *Lemon Yellow* – yellow-blue
> *Cadmium Yellow* – yellow-red
> *Vermilion* or *Cadmium Red* – red-yellow
> *Madder Red* or *Alizarin* – red-blue

Mix together the colours which have a tendency towards one another for good secondaries and those which do not for duller secondaries.

Rather than simply adding black to a colour to darken it, mix the colour which is opposite in the colour wheel or circle shown opposite. This is the complementary colour (green is the complementary colour of red and vice versa, orange of blue and purple of yellow). The resulting shade will be so much more interesting.

Similarly, just adding black to white gives a very bland grey, ultramarine and a warm brown is much more interesting, so are browns and ochres mixed as shown below.

To mix good secondaries

To make purple, mix:

blue-red

red-blue

purple

To make green, mix:

blue-yellow

yellow-blue

green

To make orange, mix:

yellow-red

red-yellow

orange

To make dull secondaries

To make dull purple, mix:

blue-red

red-yellow

purple

To make dull green, mix:

blue-yellow

yellow-red

green

To make dull orange, mix:

yellow-blue

red-blue

orange

To darken with complementaries

Reds and green

red-yellow and green

red-blue and green

Blues and orange

blue-red and orange

blue-yellow and orange

Yellows and purple

yellow-blue and purple

yellow-red and purple

To mix greys and browns

To make grey, mix:

blue-red

warm brown

grey

To make grey/brown, mix:

green

dull blue

grey/brown

To make brown, mix:

yellow-red

ochre

brown

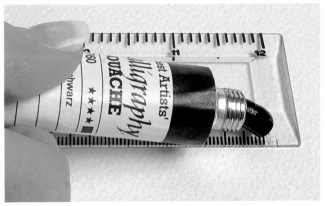

Measuring paint along a ruler will ensure that the colour mix is correct when you need to make an exact replica.

The recommended black for calligraphy is Jet Black because it is so dense and intense. For some problem papers it is often better to use Jet Black gouache rather than ink as it is more tolerant of a greasy surface. For white choose one which is opaque; permanent or bleedproof whites are good as they have opacity. Zinc white is often used as a mixing white as it does not change the basic colour. I do not use this as I prefer to have fewer tubes; mixing bleedproof white into a colour works as well for me.

Mixing the paint

Once you have your six colours of paint (plus black and white) it is recommended that you make some colour swatches for yourself which you can keep with your calligraphy materials or tape to your board for reference. This will save you having to check the previous colour mixing pages every time you want a particular green or grey.

Squeeze out a very small amount (it could be the discarded beginnings of the tubes as detailed in the next paragraph) of the six primary colours into separate white palettes or saucers and add sufficient water to each to make a liquid which is the consistency of thin, runny cream. You may like to draw some squares (circles or rectangles) on to your reference piece of paper or into a book, for good presentation. Paint each square in one of these primary colours and label it carefully.

It is all very well mixing the paints together and making the perfect colour, but what happens when you

run out and want to replicate it? It may take some considerable time to create a perfect match. To obviate this time, there is an easier way. Squeeze out a small amount of paint and then slice straight down with a wooden or plastic cocktail stick. (Some scribes attach this cocktail stick to the tube with an elastic band so that it is always to hand for a particular colour). Discard the paint you have cut off, or use it where you want the unmixed colour. Now squeeze out about 5 mm (0·2 in) along a plastic ruler and slice down the paint again with the cocktail stick. Look at the colour mixing chart on pages 108–09 and do the same for the second colour to be mixed. Add drops of water and mix the paints with a brush. If the mix is the required colour, paint a square and below it write down the colours used to mix it and the quantities you used. If the colour is not right then consider which colour needs to be added. Is the green too blue, do you need more yellow? Should you add more red to the orange? Repeat the measuring process with another 1 mm (0·05 in), and record how much extra you added each time. It can be helpful to have all the various mixes recorded in a small reference book. The green may be too blue for you this time, but could be right the next time, and it would save you so much time if you knew that that particular green was 3 mm Paris Blue and 5 mm Lemon Yellow. Simply measuring that out again will mean that the mix is the same no matter how many times you mix it.

Always add dark colours to light, as it takes less dark paint to darken a mix than light paint to lighten a mix to achieve a similar colour.

Now mix up all the dull and bright secondaries by measuring out short lengths of the appropriate two primary paints and mixing them together with water. Paint the squares and beneath each one write down the paints used and quantities. The combinations made possible by mixing varying amounts of primaries are almost endless, and making yourself a permanent record of these mixes will mean that whenever you want a particular colour, all you have to do is to refer to this and then measure out the exact amounts of paint. Darkening paints can be done by mixing in the

complementary colour. This is the colour opposite on the colour wheel (see page 108). Complementary colours react with one another, not only by darkening in a mix, but also by reacting in a vibrant way. Good green and primary red together will be quite startling, so too orange and blue, and also yellow and purple. Use these colour combinations if you want an eye-catching piece.

Complementary colours together can be quite startling.

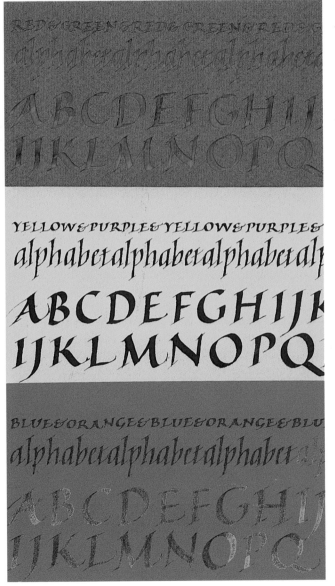

Avoid them and use similar colours – reds and oranges, blues and purples, yellows and greens if you want a softer result.

Selecting the paper

Those new to calligraphy are often concerned about using good quality paper. The concern is understandable, but not if it prevents you using it! If everything is well planned beforehand, and you are able to spend a period of time quietly writing out the words without interruption, it is unlikely that you will spoil the paper. If you do make a mistake, removing it from good quality paper (see page 118) is usually much easier than on a thin poor quality sheet, which may well have to be thrown away.

Most good quality papers are available in large sheets, which, when cut up, will give three or four smaller pieces. Choose a suitable surface; Hot Pressed is probably best to start with as it will not be such a challenge to get good letter-shapes on the smooth surface (see page 7). As you will be cutting the paper to size, you also do not need to consider the grain direction.

Deciding on the margins

Before you cut your paper, decide on the best margins using your rough as a guide. Use other sheets of coloured paper to place over the four sides of the rough. Or, better, cut L-shaped pieces from dark paper or card. When placed over the rough, these can be slid in and out at the two corners so that fewer adjustments are required (see page 112).

Remember all the time that calligraphy needs room to breathe, although you may actually choose to have very close margins on a tiny piece of work, which may almost bleed off into the margins.

Having decided on the margins, use a pencil and long straight edge to mark them on the rough. Measure and note the distance from top and bottom and from side to side before you remove the L-shaped pieces of card.

Allow at least another 3 cm (1·2 in) on each side for any adjustments and for marking out the rulings. Use a pencil and long straight edge to mark these points on your best

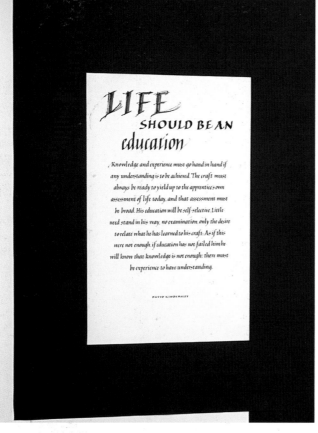
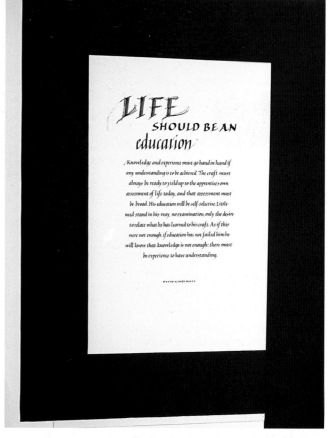

Use L-shaped pieces of dark paper to help you decide on margins. On the left, the margins are a little close, making the piece feel somewhat cramped. On the right, wider margins, where the L-shaped pieces of black card have been moved outwards, result in a more pleasing design.

paper, and use a T-square, set square or the sliding ruler of a drawing board to ensure that the lines are completely parallel and at right angles to one another. Remember to measure twice and cut once. Use a sharp knife and metal straight edge to cut out your paper.

Before you start to draw any lines on the best piece of paper, place the rough paste-up of your piece on the paper to ensure that you have not made any error with cutting it. If you spend a lot of time ruling lines only to find that the paper is too short, this will be wasted time. Then mark with a pencil on the very edge of the paper, lining up with a straight edge if necessary, the top, bottom, right- and left-hand margins of the final dimensions of your piece.

Stretching paper

If you want to write on a wash or textured background made with paint, now is the time to prepare the paper. Very heavyweight paper, over about 350 gsm, may not need to be stretched. Paper of less weight than this will, otherwise any wash will make the paper go wavy. You already have a margin of 3 cm (1·2 in) on your cut piece of paper and this will be sufficient to allow for stretching. You will need a wooden board, larger than the paper, and lengths of gummed paper tape – two pieces for the top and bottom, and two for the sides. Cut the paper tape and place them to hand. Place the paper on the board and with cold water and a clean sponge apply water all over the paper so that it is wetted but not completely soggy. Moisten a paper tape strip for one of the longest sides and attach it to one edge of the paper, allowing for an overlap of about 1–1·5 cm (0·4–0·6 in). Repeat this for the opposite edge, but just before attaching it to the board, very slightly stretch the paper so that it is under tension. Apply the strips to the remaining sides. Allow the paper to dry (see opposite).

Any wash should be applied to dryish paper, otherwise the paint will immediately sink into the valleys (although this

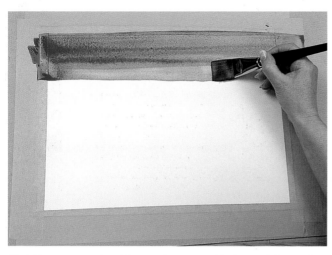

Stretching paper on a board for a wash or textured background. Gummed paper tape is the best for anchoring the paper to the board.

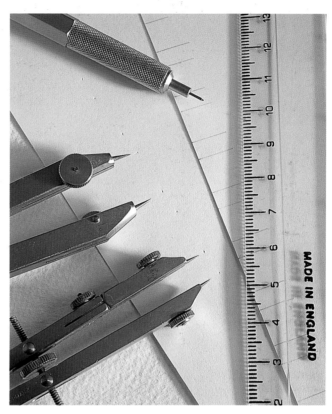

Measuring lines can be done either with a straight edge, or by transferring the measurements using a piece of paper, or, preferably, by using sets of dividers to make a series of pin-pricks in the margin which indicate the lines for x-height and the interlinear spacing.

could be your intention). Mix up paint of the required colour and experiment with the dilution. Generally a wash should be more dilute than that for writing. It is better to make it more dilute as you can always add another coat, but not remove it if it is dark and heavy.

Start at the top of the paper, using a wide, soft wash brush dipped into the paint and make one broad horizontal stroke. Do not stop as you do this. Dip the brush in paint again and make a second stroke just underneath, so that there is a very slight overlap. All this should be done while the paint is wet. Once you allow any part of the wash to dry, you will not get a smooth finish, and there will be an obvious line. Add salt, place clingfilm on top, drop in other colours or what you will to add interest to your wash.

Allow the wash to dry completely before removing the paper from the board. Trim off the gummed paper tape. See page 115 for writing on a wash.

Measuring lines for x-height

It is important when you are working on a best piece to measure the guidelines for your letters and the spaces between these lines carefully. Particularly with a small nib, any slight discrepancy will result in some guidelines looking wider apart than others.

Measuring these distances can be done in three ways. First, and perhaps most obvious, is to use the measurements on a ruler. This is fine if the markings are accurate and narrow, but on most cheap rulers they will be too wide for the accuracy that you may need. Probably the markings on a metal ruler or straight edge are the best as they can be etched the finest. You also need to ensure that your pencil is sharpened to a very fine point, and remember that it should be hard, a 4H.

Another simple way is to copy the markings directly from the first measurement on to an off-cut of paper which has a straight edge, again with a very sharp pencil. The paper can then be placed against a drawn vertical line and the measurements simply marked off against those on the paper.

Both these methods do allow for a degree of inaccuracy, and the method that I prefer is to use dividers. These are similar to sets of mathematical compasses, but have two points at the ends of the arms instead of one point and a pencil lead. Most sets of reasonable quality compasses will be supplied with a spare point, so it should be relatively easy to convert compasses into dividers. If you have more than one set of dividers, you can use one for the x-height, one for the interlinear height and one for any other sets of lines you need to mark. The best compasses are those which have a central wheel between the arms so that the measurement will remain constant when handled.

Place one point of the dividers at the top line for x-height and rotate the wheel so that the other point is at the lower line. With the other set of dividers, place one point on the lower line for x-height and the other point at the upper line for x-height on the line following. Draw a vertical line in the margin of your paper. The pin-pricks marked here will eventually be trimmed off. It is then a simple matter to start with the first set of dividers to mark the top of the first line of writing. First mark the two points for the x-height of the top line. Now place the second set of dividers for the interlinear measurements so that the first point goes into the lower pin-prick mark for x-height, and mark the lower point. Use alternating sets of dividers for as many lines as you need to mark. Pin-pricks, with dividers held constant by the central wheel are the most accurate way of marking lines.

Dealing with problem papers

In an ideal world you would never have to treat paper specially, simply use paper which is ideal for the purpose. Occasionally, though, paper which does not have the best surface for calligraphy is the most appropriate colour, or the paper may have been supplied by a client, or is already bound into a book in which you have to write a name or inscription, or you want to write on a wash.

If the paper is fluffy or has a raised texture, such as some hand-made or a Not (Cold Pressed) or Rough paper, it is possible to create a smoother surface by burnishing or calendering it. This is done with the bowl of a metal spoon, or a very smooth stone or an agate burnisher. On a test piece, experiment to see how much pressure you need to exert to make the finished surface required. Sometimes only a few stray fibres need to be pressed down, in other cases a degree of pressure has to be exerted to push out an unsuitable texture.

Some papers, occasionally those in prestigious books, especially if they have been handled, are rather greasy. This means that when you want to write a letter the stroke is not consistent and looks as if there is uneven pressure with the paint not being distributed evenly. Try first on a test piece using a soft eraser which may remove surface dirt and grease. Probably, though, pounce will be necessary. Pounce is a mixture of ground pumice stone

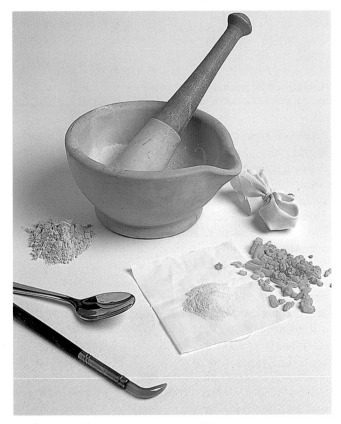

Treat problem papers by burnishing a textured surface with the back of a spoon or burnisher, using pounce and/or powdered gum sandarac.

Making a mask for your piece will ensure that you draw lines only where they are needed and not across the whole sheet of paper.

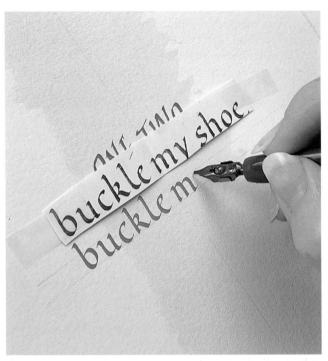

Attaching a strip of the rough design with tiny pieces of masking tape just above where you are to write should ensure that you make fewer mistakes as the individual letter is positioned within your eye-line and just above where you are to write it.

(from volcanoes) and ground cuttlefish bone. The pumice is gritty and absorbs the grease; the cuttlefish bites into the surface and raises the nap of the paper slightly. Most pounce now sold is pumice only. Working on a test piece again, sprinkle the grey pounce powder over the surface. Either using a piece of cotton wool, or a small scrap of paper, or the pads of your (clean) fingers move the pounce over the paper in a circular motion. Try not to press down too hard, as the surface of paper is very uneven and the pounce could remain in the interstices. When all the paper has been covered, fold a piece of scrap paper in half making a crease down the middle and place this on a flat surface. Tip the treated paper over this sheet and tap it to remove as much pounce powder as you can. Go over the paper now with a soft brush allowing the powder to fall on to the horizontal sheet. When you have finished, all the pounce powder can be poured easily into a small screw top jar for re-use. Remember, too, that gouache, rather than ink, may be the better choice to use on greasy papers.

Other papers may have a surface where the ink or paint spreads too easily, and so your letters do not show those fine, hairline strokes which you would like. Also, if you are to write on a wash, the paint will bleed into the wash if it is not treated. These papers should be treated with powdered gum sandarac. This is a resin which is usually sold as yellow crystals covered in a pale-yellow powder. Do handle this carefully as it can cause allergies – wear a mask and protective gloves. The crystals should be ground to a fine pale-yellow powder in a pestle and mortar. Powdered gum sandarac acts as a slight resist and so should be applied only where there is to be writing. If it is spread all over the paper and the excess is not removed then it is very difficult to apply paint. The powder can either be applied over the surface of the paper in a similar way to pounce, or you can make yourself a sander. This is a little fabric pouch of a finely-woven fabric, such as an old handkerchief or small square (10 cm/4 in) from a pillowcase. Place the

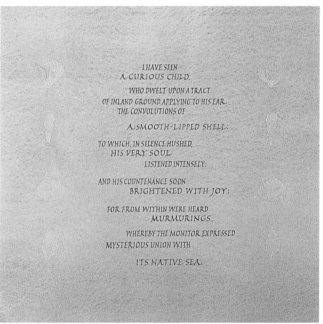

Writing out a broadsheet using colour. As before, the words were written out in the styles which I thought most appropriate. Some words and phrases were rewritten if I thought the spacing was suspect. The photocopy of this was cut up to my preferred line length and some of the smooth-lipped shells were inserted in outline. The idea was to have the shells either side of the words and just visible. I outlined them in a narrow pen nib and masking fluid, and applied washes of sky blue, green for the countryside and sea blue on stretched paper. Once dry, I cut the paper from the stretching board, removed the masking fluid, applied gum sandarac where I wanted to write, and used a mask (see page 115) for drawing out the guidelines before I wrote the piece.

powdered gum sandarac inside, gather up the edges and tie them with string. Dab the sander over the areas you want to be treated and then remove the excess with a brush. Take care here not only to avoid breathing in the particles, but also not to overuse the sandarac. Gum sandarac is a very effective resist when used properly. There is a tendency, and I have done this myself, for over-zealous application. This results in strokes which have two sides and no middles, and, on important, complicated pieces, I have sometimes had to spend much time painting in the middles of letters!

Setting out your paper

Having used paper markings, a ruler to measure or, preferably, sets of dividers to mark out pin-pricks which indicate the x-height and the interlinear spaces between the lines on the very edge of the left-hand margin on the paper, you are now ready to draw the lines.

It is best not to draw lines completely across your piece of paper from left to right. Even when these have been erased it is often possible to detect where they have been because of an indentation in the paper.

Use a straight edge to mark on the right margin, or vertical centre line, or left margin, according to how your piece is to be laid out, but draw this line from the top to bottom of the writing area only, as indicated by the pencil markings or pin-pricks in the margin.

If your layout is right or left aligned, then most of the lines will probably be within a text block, and you could now draw faint guidelines with a very sharp 4H pencil and straight edge across the block of where the lines will be written. On the other hand, you may choose to draw guidelines only where the writing is to be. This is particularly important if your piece is centred, where the right and left margin will no doubt be ragged. You will certainly want your line drawing to be more exact and not extend beyond the area of writing. Either measure each line on your rough, and the distance on the left and right from the centre point, and draw the line on the best paper accordingly. Alternatively, remove the strips from the paste-up (if convenient, you may want to photocopy the

final paste-up first), and line up the drawn vertical line on the strips with that on the actual paper. Draw guidelines then which extend from the left to the right point of the writing on each strip.

Dark papers need special treatment. Often it is almost impossible to erase on these without detection, and it may be best to leave the guidelines in place. If you only draw the guidelines where you are to write they are often covered by the lettering and so do not show. Either draw lines as explained in the previous paragraph or make a mask as an aid. Place a piece of suitably sized layout or tracing paper over the pasted-up rough. Use a pencil to mark on the beginning and endings of each line. Before and after these markings for the lines mark also the x-height and spaces between the guidelines – take care to be accurate here. You may wish to use dividers for these measurements. With a sharp knife, accurately cut out the layout or tracing paper between these line markings so that there is a hole in the middle of the paper, but the measurements for x-height and interlinear spacing are still visible. Place this mask carefully on the best paper, lining up the top and bottom, right and left margins so that the lines will be in the correct position on the paper. Attach the layout/tracing paper with tiny pieces of masking or magic tape. Use a suitable implement for drawing straight and parallel lines and a pencil to faintly mark on the correct guidelines. Even though your pencil will probably go over the area for writing this will mark the layout/tracing paper mask and not the dark paper itself. Remove the mask and write on the lines.

Writing the piece

Now you are ready to write the piece. Use tiny pieces of masking tape to attach the first strip of writing just above where you are to write, allowing for the ascenders. This will ensure that you write the correctly spelt words in the right order. Most people tense up at this point. To avoid this, place a piece of rough paper with guidelines over where you are to write. Copy out the first few lines until you feel the tension in your hand, arm and shoulder easing as you enjoy using the pen. When you are more relaxed, remove this paper and start on your piece.

To speed things up, when you have written each line, check it against the attached strip, and when you are sure it is correct dry the paint or ink with a hair dryer. This will prevent you having to sit and watch paint dry!

When the piece is finished, remove the guidelines if necessary. The best erasers to use are soft ones with a fine edge so that they can remove the pencil markings between the individual strokes. These are sometimes available in triangular shapes and sometimes held within a plastic protective covering, with a system where the eraser can be slid up for use. Erase carefully, and try not simply to rub hard horizontally in order to remove the lines. If the paint is slightly fugitive, or, if it is not completely dry, it may smudge along your beautiful lettering and spoil the piece.

Trim the edges of the paper with a sharp knife and straight edge, removing the pin-prick marks as you do so. However, do not throw this strip away. Write on it what the markings are for, the final dimensions and what the piece is. If you ever want to or are asked to repeat the piece, you have an accurate record of the measurements which can be easily transferred to a new piece of paper by pushing the point of a set of dividers through the pin-pricks.

Dealing with mistakes

Concentrating on how to make the letters, the shape of the bowl, the serifs, feeding ink into the pen, whether the sharpened nib will pick up any paper fibres and mess up a letter – all these and more mean that calligraphy can be so exacting that, even though you know that the last letter of 'and' is 'd', somehow or other you manage to miss it off altogether. Or perhaps one of those paper fibres was picked up by the nib and pulled across the bottom of the bowl of a letter 'e' making a nasty blur. What can be done to rectify these problems?

You have three choices. Writing in an already bound book, or somewhere where it is not possible to make an unobtrusive correction, means that you will have to correct the omission in the least obvious way. A tiny symbol in the margin and the line written at the bottom or the end of the passage is the best way for an omission.

A letter that has been missed out should similarly be positioned as close to the mistake as possible without jarring the eye.

If the mistake is quite near the beginning, the paper is not that expensive and you did not have to draw too many guidelines, then you may choose to start again. This may save you the most time and effort. As well as this, if the mistake is that a complete line, or a large part of a line is missed, or the mistake will mean having to erase half a line of text, then again, it is probably best if you start again. However, do not throw away what you have written in despair. Some might be retrievable as a shorter text, or use it to make cards which use pieces of calligraphy as background pattern. Look back at Chapter 3 for some ideas.

If, however the mistake is small, perhaps one letter written in error, or a mistake towards the end of a line which will mean not too much work to rectify, then it is worth trying to save the piece. If you chose good quality paper to start with, at least 150 gsm or more, then you do have a good opportunity to erase and rewrite the error. Rarely is it sufficient just to use a hard eraser, such as an ink eraser to remove the offending letter. Usually, although this will remove some, if not all, of the ink or paint, it is likely to roughen the surface so much and remove a lot of the paper (it may even make a hole if you erase too vigorously!) that writing over what is left of the paper is likely to show and draw attention to the mistake.

You can use a very sharp, flexible blade, such as a razor blade. Take care when handling. Bend it slightly and use it to scoop a tiny amount of the paper from the surface. If you do not remove the complete error then repeat. This is a very skilled job and you may prefer the second method. This takes more time but does not require so much skill. With a very clean, fine brush (about a 0 in size), dip the brush in clean water, wipe it on the side of the water pot and paint over the offending stroke(s). Immediately dab with a clean folded paper kitchen towel to absorb the moistened paint. Repeat this again and again until no more paint comes off on to the paper kitchen towel. Allow to dry thoroughly; this is important because if the paper is at all moist, any erasing will

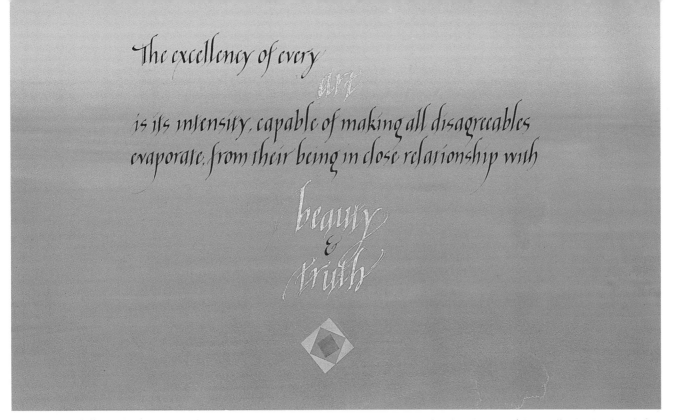

The excellency of every art is its intensity, capable of making all disagreeables evaporate, from their being in close relationship with beauty & truth

Three words in this quotation stood out – 'art', 'beauty' and 'truth'. It took some experiments with the layout to ensure that they were central and the rest of the words floated around them. Once I was certain of the layout and where the words and lines were positioned, I stretched the paper, wrote the three words freely in masking fluid with a large nib, without any guidelines or pencil marks to help. Once that was dry I applied the washes of red, orange and yellow. When that was dry, the masking fluid was removed, and the paper cut from the stretching board. I then completed the rest of the quotation. Lastly I went over the large three words with gold calligraphy gouache, and added three small coloured squares at the base to complete the design.

create a hole. After an hour or so then gently rub over the just visible stroke(s) with an ink eraser. Do this with patience rather than vigour. Eventually all the paint will be removed.

Most papers are tub sized, that is, sized throughout the paper. Place a piece of thin paper, such as layout paper, over the area of erasure and rub over with the back of your fingernail or a burnisher. This presses down any paper fibres which have become loosened by the erasing, without polishing the paper, which occurs if you do this directly. You can now write over where the mistake was made.

If the paper is sized only on the surface then writing over this area will result in letters where the ink bleeds into the surrounding paper. The paper will then need to be re-sized before you rewrite. There are many ways in which this can be done, making your own size from starch is one of them, but I prefer to use a very dilute solution of PVA. Test it on a small area first to know how much the dilution should be to successfully re-size the paper but not make the area sticky.

Conclusion

This book has shown you how easy it is to make beautiful letters using simple tools and materials, how to use those letters to create stylish, attractive and individual cards and bookmarks, letters and words which can decorate wraps, folds, bags, boxes, how to make hand-lettered invitations, menus, little books of many varieties and how to letter your own broadsheets. Now it is up to you to use your new-found skills and enjoy them as much as you can.

glossary

archival paper Paper which is acid-free and so will last longer without affecting the colour of painting or writing.

arch The curved part of the letter as it joins the downstroke.

ascender The stem of the letter which extends above the x-height as on letters *b*, *h*, *k* and *l*.

Automatic pen Type of pen which has a wide tip and a large reservoir for writing big letters.

body height The x-height (see **x-height**).

bone folder Often used by bookbinders to assist in folding and scoring paper; made of bone or plastic and blade-like. The most useful have a curve at one end and a point at the other which can be used to press down corners.

bookbinder's corner Way of making a cover for a book which ensures that the corner is neat and totally covered by paper or fabric.

bowl The round or oval curved part of a letter.

broadsheet A piece of calligraphy which is usually mounted and framed, possibly to hang on the wall, as opposed to calligraphy on a scroll or in a book.

burnisher Polished metal or stone which is used to polish metal leaf or to smooth paper.

Coit pen Similar in form to an **Automatic pen** but with a central rippled reservoir.

Cold Pressed paper *See* **Not**.

concertina books Also **zig-zag** books; books made from a long strip of paper folded to resemble a concertina or zig zag.

cross bar The horizontal stroke on a letter such as *t* or *f*.

deckle edge Slightly rough or uneven edge of paper made by small amounts of the paper pulp seeping out between the mould and deckle when the paper sheet is made.

descender The stem of the letter which extends below the x-height as on letters *p*, *q* and *y*.

dividers Technical drawing implements which have a point at the end of each arm, used for marking the position of lines.

embossing Pushing paper though a hole in a cut-out stencil so that the paper becomes raised from the rest of the surface.

endpapers The first and last folds of paper in a book which attach the pages of the book to its cover.

fishtail serifs The beginnings or ends of letters where the stroke divides like the tail on a fish.

flourishes Strokes added to letters, often ascenders and descenders, but also to cross bars, to extend them in a decorative way.

gouache Paint, like watercolour, but opaque; often used by scribes as it does not show lines or repeated strokes when mixed to the appropriate consistency.

grain direction The direction in which manufactured paper folds and tears most easily; essential to consider when bookbinding. The fold should be parallel to the grain direction.

guard sheet A piece of paper covering the lower part of a calligrapher's board behind which the paper slips while in use, thus preventing it from becoming dirty.

guidelines Lines usually drawn in pencil or with a hard point to indicate where letters and words should go.

gum sandarac Lumps of hard gum crystals which are ground into a powder and applied to paper to improve the surface for writing.

Hot Pressed paper (HP) Paper with a smooth surface.

interlinear spacing Spacing between lines.

laid paper Paper which shows the laid lines.

letter families Groups of letters where similar strokes are used in their construction.

majuscule Capital or upper case letter.

manuscript books Books made by hand.

minuscule Small or lower case letter.

Not paper Paper which has been passed through cold rollers, not heated rollers. The resulting surface texture being between Hot Pressed and Rough.

paste-up Lettering or painting positioned in place as exemplar for best copy, or pasted-up for printing or photocopying, where the best examples are attached to a backing surface.

pounce Powdered pumice and cuttlefish (sometimes) used to remove grease in paper.

reservoir An attachment to a pen nib to hold ink.

Rough paper Paper which is allowed to dry naturally after being made, i.e. not passed through any rollers; the resulting surface texture is very uneven.

ruling pen A pen made from two pieces of metal, or one piece folded over, where either a central screw or the position and angle of the pen give strokes of varying widths.

serif The stroke at the beginning and end of a letter, sometimes made as part of the initial stroke.

weight of paper The weight of paper related to its area. In most countries this is referred to as its weight in grammes per square metre, or gsm or gm^2.

wove paper Paper which does not show laid lines.

x-height The height of a small letter x of the alphabet under consideration. This changes according to the width of the nib being used.

zig zag books *See* **concertina books**.

index

Quotations used in this book:
Pages 18, 104, William Shakespeare, *Henry IV, Part 2*
Pages 19, 27, 35, 41. William Shakespeare, *Hamlet*
Page 21, William Shakespeare, *The Tempest*
Page 29, Edward Thomas, *Tall Nettles*
Page 90, John Ruskin, *Sesame and Lilies: Of King's Treasuries*
Page 91, Ann Bradstreet, *To My Dear and Loving husband*
Page 92, William Ellis, *Making Coffee*
Pages 95, 96, Katherine Mansfield, *The Garden Party*
Page 100, John Evelyn, *Diary*
Page 103, Lorenzo de Medici, *Trionfo do Bacco ed Arianna*
Page 105, *Nursery counting rhyme*
page 107, Edward Thomas, *The Hollow Wood*
Page 107, Edward Thomas, *Bright Clouds*
Page 112, David Kindersley, *Life should be an education*,
(extract from *Apprenticeship* by Gayford, Kindersley and
Cardozo Kindersley) reproduced by kind permission of Lida
Lopes Cardozo Kindersley
Page 116, William Wordsworth, *The Excursion*
Page 119, John Keats, *Letter to G and T Keats, 1817*